IMAGES
of America

PALOS VERDES
ESTATES

A logo of Palos Verdes Estates represents a city with a great future and a remarkable heritage, presented on the following pages. (Courtesy of the City of Palos Verdes Estates.)

ON THE COVER: One of Palos Verdes Estates's most beloved and recognizable landmarks, Malaga Cove Plaza's Neptune Fountain, is depicted on the day of its dedication, February 16, 1930. King Neptune and his risqué mermaid and cupid companions have greeted visitors entering Palos Verdes Estates from the east and north for 80 years. Emile Pozzo, past president of the Italian Chamber of Commerce of Los Angeles, and several other dignitaries offered warm greetings and congratulations to Palos Verdes on the community's splendid fountain and beautiful locale. (Courtesy of the Palos Verdes Library District, Local History Collection; photograph by Julius L. Padilla, Padilla Studios, Los Angeles.)

IMAGES
of America

PALOS VERDES
ESTATES

John Phillips

ARCADIA
PUBLISHING

Published by Arcadia Publishing
Charleston, South Carolina

Printed in the United States of America

Library of Congress Control Number: 2010926982

For all general information, please contact Arcadia Publishing:
Telephone 843-853-2070
Fax 843-853-0044
E-mail sales@arcadiapublishing.com
For customer service and orders:
Toll-Free 1-888-313-2665

Visit us on the Internet at www.arcadiapublishing.com

*For my grandfather John Edward Phillips, who enjoys
recounting the stories of his youth, especially of the 1920s
and 1930s, when he delivered newspapers to the Palos Verdes
Project architects offices at Malaga Cove Plaza.*

CONTENTS

ACKNOWLEDGMENTS

My sincerest gratitude goes to Marjeanne Blinn, the extremely capable director of the Local History Collection of the Palos Verdes Library District, for her enthusiasm, insight, and patience. Thanks must also be expressed to Therese Anlauf and the other wonderful volunteers of the Local History Room and the ladies at the Palos Verdes Homes Association, who put up with my periodic rummaging. My appreciation extends to the friends and neighbors who shared their knowledge and gave me encouragement.

Credit is duly given to the writers and editors of the *Palos Verdes Bulletin* and *Palos Verdes Peninsula News* as well as to Delane Morgan, the author of the wonderful book *The Palos Verdes Story* and Augusta Fink, author of *Time and the Terraced Land*, which were tremendous sources of knowledge about the Palos Verdes Peninsula. I would also like to recognize the man behind nearly all the photographs in this book, Julius L. Padilla of Padilla Studios, Los Angeles, who was hired by the Palos Verdes Project to document the development of the community, its personalities, architecture, and natural beauty. Padilla captured so well a unique event: the birth and blossoming of an idealistic new community.

Of course, my heartfelt thanks are deserved by my wife, Carmen, and our boys—Charlie, Tommie, and Henry—for granting me the time to undertake this exercise in self-indulgence. Unless otherwise noted, all of the images are courtesy of the Local History Collection of the Palos Verdes Library District.

INTRODUCTION

The story of Palos Verdes Estates is one of pioneers and seekers, of idealists and opportunists, and of good people of diverse origins unified in their desire for quality lives. The story begins long before New York banker and financier Frank A. Vanderlip and his associates took a chance on the 16,000-acre peninsula known as Palos Verdes, buying it with a mere $1.5 million in 1913. This illustrated history focuses largely on the period following that fortuitous speculation. However, a portrait of the peninsula before Vanderlip seems fitting here, especially covering the 3,065 acres that became the city of Palos Verdes Estates in 1939.

Portuguese explorer Juan Cabrillo first "discovered" the Palos Verdes Peninsula, claiming it for Spain in October 1542 during his journey northward along the California coast. He died less than three months later. While anchored at Santa Catalina Island, he encountered armed Native Americans but was eventually able to befriend them. Evidence of continuous human habitation of the island is estimated at approximately 7,000 years. These were the Tongva Indians, whose domain encompassed the Palos Verdes Peninsula, including Malaga Cove, where archaeological remains of a long-occupied village site were discovered during the early development of the Palos Verdes Project.

Further contact with European explorers and traders may have occurred as early as 1565 with the establishment of the Acapulco-Manila trade route. Sebastian Vizcaino led an expedition in 1602 with the purpose of mapping the California coast. Toward the end of the 1600s, colonial outposts began to appear, followed by presidios to protect against Russian infringement. Eventually the missions were established for the stated purpose of religious conversion, the result being the collection and integration of the Native Americans into the controllable social structure desired by the colonial authorities in Mexico.

The Mission San Gabriel Arcangel was established in 1771, and the many local Native Americans (thereafter known as the Gabrielinos) were gathered up together at the mission compounds. The lands opened up by the removal of the Native Americans were divided up into ranchos and permission was given by the Spanish crown to loyal soldiers for settlement and grazing. One such recipient was Juan Jose Dominguez. In 1784, he was awarded the concession of Rancho San Pedro, some 75,000 acres, part of which was the Palos Verdes Peninsula. In 1809, Jose Dolores Sepulveda was granted permission by the executor of Dominguez's will to graze the smaller portion (31,629 acres) of the original Rancho San Pedro, known as Rancho de los Palos Verdes. This was contested by members of the Sepulveda family. Eventually Juan Capistrano Sepulveda and Jose Loreto Sepulveda were awarded possession of the rancho.

By 1882, portions of Rancho de los Palos Verdes, now part of the United States (via the Treaty of Guadalupe Hidalgo in 1848), had changed hands again. This time, the bulk of what is known as the Palos Verdes Peninsula, some 17,000 acres, ended up in the hands of Jotham Bixby. In 1894, Jotham's son George took over and, as early as 1906, leased land to Japanese farming families whose descendents work the ground locally to this day. George Bixby hired Harry Phillips to manage the ranch, raising cattle and horses and farming as well.

The year 1913 marked the purchase of 16,000 acres, essentially the entire peninsula (1,000 acres were kept by Bixby), by Frank A. Vanderlip and around 50 wealthy associates after earlier deals,

one involving E. L. Doheny and another with Walter Fundenberg, could not be closed. Vanderlip, a man of action, immediately began assembling an impressive team to help with the planning and development of the peninsula. He selected the Olmsted Brothers of Brookline, Massachusetts, a renowned landscape design firm with whom he had previously worked, to prepare plans for a "high class residential district."

He hired prominent architects Myron Hunt and Howard Shaw to collaborate on plans for a sprawling mission-style country club to be perched on the bluffs of Portuguese Bend. They had completed renderings by May 1914. Sadly, events in Europe and America's entry into World War I drew the attention of Vanderlip and his associates away from the peninsula on the Pacific and to war efforts at home and abroad and work ceased. After a brief recommencement in 1916, the project again went into hibernation. After the war, Vanderlip no longer had the desire to undertake the development.

In 1921, Vanderlip began dealings with E. G. Lewis, a real estate promoter, publisher, and oilman (among other pursuits) who was, by all accounts, a somewhat slippery fellow. It is curious why a seasoned businessman and giant of the financial world such as Vanderlip would take a chance on a man who had previously been indicted by a grand jury for mail fraud. Lewis obtained an option on the land for $5 million and began an escalating, aggressive sales campaign to raise additional capital through subscription offers to private underwriters for the development of the peninsula. He was able to raise some $15 million, but it was not enough. In 1923, the Title Insurance and Trust Company, trustee, terminated its support, and returned the investments to the subscribers. Lewis resigned two months later. With the property back in the hands of Vanderlip's syndicate, the Commonwealth Trust Company was formed using roughly $1 million from the original capital, to buy 3,225 acres. Thus, a scaled down version of the original project was undertaken and named Palos Verdes Estates.

With infrastructure work well underway and a team of talented individuals on board, many of whom stayed on following the Lewis era, promotion and sales were the order of the day. The period beginning in 1923 and ending with the stock market crash of 1929 would be the most formative period in the history of the fledgling community. Guided by idealism and romance and, of course, the thirst for profits, the founders peddled not merely magnificent home sites, but a lifestyle. This "New Town," as they called it, would be protected by the Homes Association, with its Art Jury and protective deed restrictions to ensure the high character and quality of the seaside suburb, located generally as the northwestern and western portions of the peninsula along the most southern extent of Santa Monica Bay. The wide ranging restrictions addressed a plethora of issues, including the architectural style allowed in particular districts, the minimum cost of each home based on lot size, the color of walls, erection of fences, and the visibility of one's drying laundry to name a few. Unfortunately, as in other suburban developments of the time, there was a dark side to the "protective" restrictions, as they prohibited persons of non-Caucasian descent, excepting those serving in domestic capacities.

The nucleus of the early social scene was established largely by the members of the Palos Verdes Project team, many of whom decided to make Palos Verdes their permanent home. Early project members who chose to settle here with their families included Charles Cheney, Frederick Law Olmsted Jr., Jay Lawyer, Donald Lawyer, Col. J. C. Low, Brooks Snelgrove, E. W. Harden, Harry E. Benedict, George Gibbs, Farnham Martin, Howard Towle, Eulogio Carrillo, James Dawson, Lawrence Hussey, Hammond Sadler, F. F. Schellenberg, and William H. Munroe. These and other pioneer families worked and kept company with one another, and their children played and attended school together.

Through the years, the empty lots have been built upon, the trees have matured (there is an abundance of *verde* in Palos Verdes), and the graceful edifices of the Palos Verdes Golf Club Clubhouse, Malaga Cove School, La Casa Primera, El Portal, and La Venta Inn remind us of the golden days when the dreams of the founders were being made reality and our old sentinel, Neptune, began his enduring watch over us.

One

COSTA ENCANTADA
A ROMANTIC VISION FOR AN UNBLEMISHED LANDSCAPE

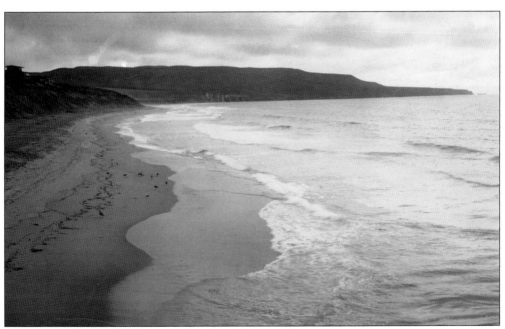

In 1913, a group of wealthy investors from the East Coast led by Frank A. Vanderlip completed the purchase of 25 square miles of open hills and pristine seacoast dotted here and there with ranches and farmhouses. It is generally known that Vanderlip bought the bulk of Rancho de los Palos Verdes, as it was formerly known, "sight unseen," although he did send some of his men to scout it out beforehand.

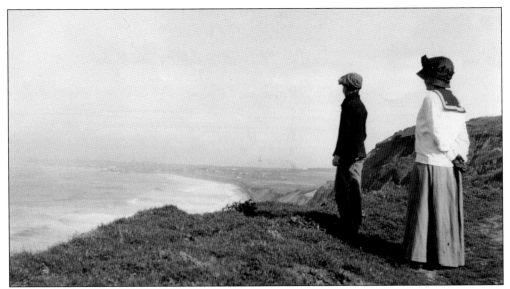

The Phillips were among the early ranching families of the Palos Verdes Peninsula. Harry Phillips was hired by George Bixby in 1894 to manage the ranching operations and is said to be the first resident of the peninsula, following the Native Americans of course. Leslie and Mabel Phillips enjoy the view of Santa Monica Bay from the bluffs at Malaga Cove in 1912.

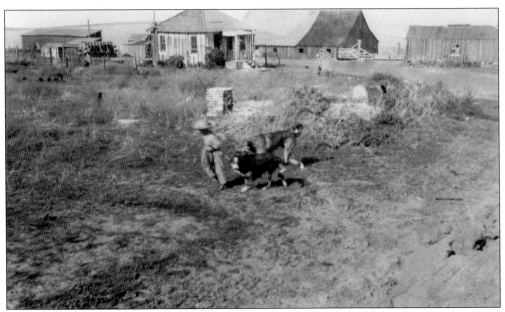

The ranch house, barn, and other structures of Henry Phillips Jr. were near the east end of the current Palos Verdes Golf Club, adjacent to the Malaga Cove district. The image is from 1916, around the time Vanderlip saw the peninsula for the first time. The boy is Leroy Phillips, son of John A. Phillips, nephew of Harry Phillips Jr.

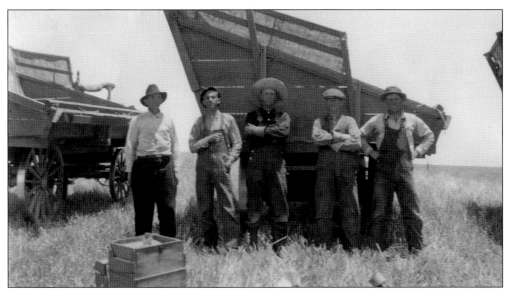

In this image from 1915, John "Jack" Phillips, in the wide-brimmed hat, stands between two of his farmhands among pieces of his farm equipment. Born in 1887, John was the first son of Harry Phillips Sr., ranch manager. Crops grown at the time included lima beans, barley, and grains, and the ranch eventually grazed 2,000 cattle.

In 1915, John Phillips (left) is seen with Dan Gridley, a famous opera tenor of the 1920s and 1930s, and an unidentified young boy. The land by this time was in the hands of the Vanderlip syndicate. However, there were no new structures built until 1916, the first being Vanderlip's own Old Ranch Cottage, as it was known.

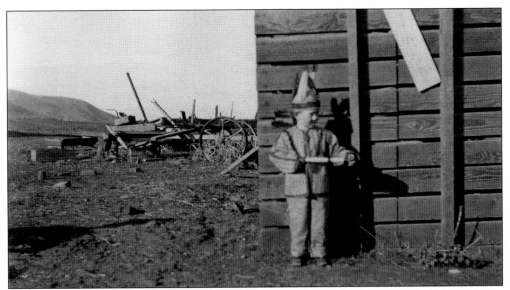

On the Phillips ranch near the future site of the Palos Verdes Golf Club, Leroy Phillips, in Native American costume, plays with a pop gun. Leroy (1911–1992) was the youngest son of John A. Phillips. This image from 1915 shows the still barren hills, which would eventually receive lush landscaping through the visionary design of the Olmsted Brothers firm.

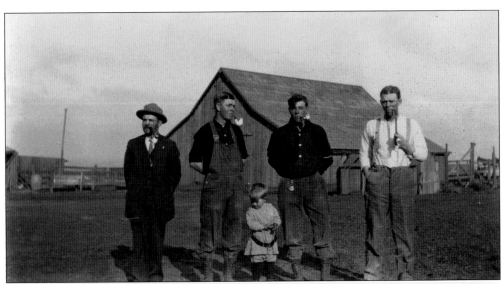

Standing from left to right are George Taylor's uncle (name unknown), Harry F. Phillips Jr. (1889–1980), young Leroy Andrew Phillips (1911–1992), George Taylor (husband of Mabel Phillips), and John "Jack" Phillips (born 1887). This photograph was taken at the Phillips ranch near Malaga Cove in 1915.

This view looks north toward the Santa Monica Bay, around 1915, on the ranch of Raymond McCarrell, son of Roy McCarrell Sr. (one of the early ranchers from the Jotham Bixby era of peninsula ownership). The ranch was near what became Palos Verdes Boulevard, the northern entrance to Palos Verdes Estates at Malaga Cove.

A 1920 view looks across the fields that eventually became the Palos Verdes Golf Club. The McCarrell Ranch and a team of horses or mules are visible. Harry Phillips Sr. planted the eucalyptus groves along the northern border of the ranchlands that would come to define the Valmonte neighborhood.

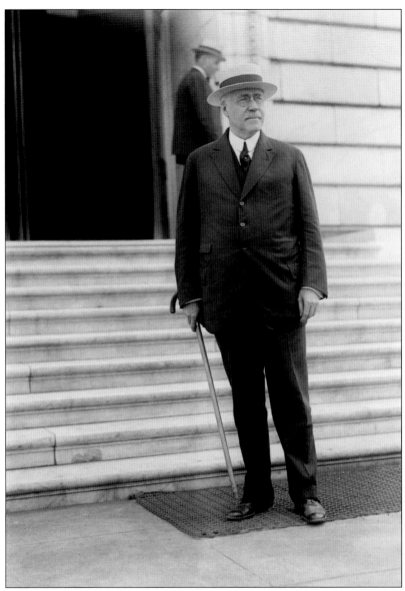

Frank A. Vanderlip, pictured here in 1918, was assistant secretary of the U.S. Treasury during President McKinley's second term and president of National City Bank from 1909 to 1919. Following Walter Fundenberg's failed bid to purchase the Palos Verdes Peninsula from George Bixby in 1913, Vanderlip assembled a syndicate of wealthy associates to finance the purchase and development of the peninsula. By 1914, he had his dream team assembled. He called upon Olmsted Associates of Brookline, Massachusetts, to begin the layout of streets, parks, and building sites. Howard Shaw of Chicago and Myron Hunt of Los Angeles prepared preliminary drawings for a grand mission-style country club with long colonnaded facades and numerous towers to be located near Portuguese Bend overlooking a new golf course, as reported in a *Los Angeles Times* story of May 17, 1914. Despite several setbacks, including the onset of World War I, illness, and a failed divestment to much maligned real estate promoter E. G. Lewis, Vanderlip maintained ties to Palos Verdes. He kept his estate home in the Portuguese Bend area until his death. Members of the Vanderlip family hold the estate to this day. (Author's collection.)

The enigmatic Edward Gardner Lewis (1868–1950) played a key role in the development of Palos Verdes Estates. Lewis was the inventor of myriad get-rich-quick schemes and was also a publisher, oil speculator, real estate promoter, and founder of University City, Missouri, and Atascadero, California. Trouble and controversy seemed to be his constant companions. He was bankrupted multiple times and ultimately sent to federal prison upon his conviction for mail fraud. Regardless of his tarnished legacy, he was instrumental in the shaping of the Palos Verdes Estates we know today. Lewis arrived on the scene as a result of the loss of interest in Palos Verdes by the Vanderlip syndicate, which was brought about by the events in Europe leading up to World War I. He immediately and vigorously promoted his own grandiose plan for the peninsula. He kept the Olmsted firm and Myron Hunt on board from Vanderlip's original design staff, then added his own army of eminent planners, surveyors, and engineers. Chief among Lewis's talented recruits was Charles Cheney, a leader in city planning who would remain involved with the city of Palos Verdes Estates for the rest of his life.

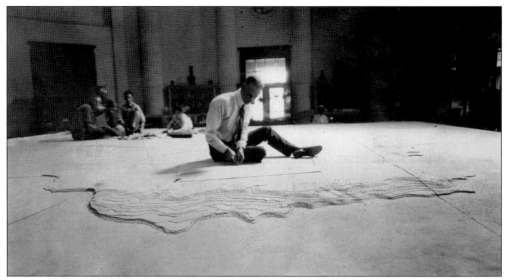

Using the *Los Angeles Times* as well as his own publication, *The California Illustrated Review*, E. G. Lewis ran a profusion of advertorials and features to announce and market the venture. Lewis's ads soliciting subscriptions for shares in the Palos Verdes venture ran next to offers to invest in his pumpkin flour factory, almond farms, and oil well partnerships. For promotion of the Palos Verdes Project, he commissioned a large diorama, photographed here in 1921.

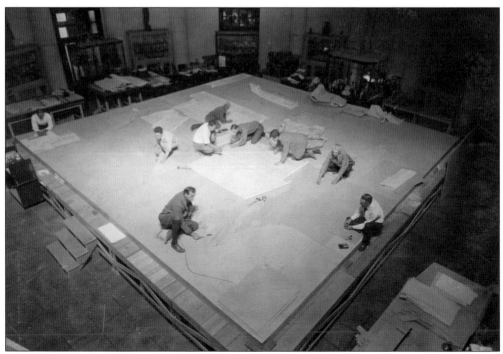

J. T. Edwards of Atascadero and his associates constructed the diorama, an exact scale model of the entire peninsula measuring 25-feet-by-35-feet. It is believed that the model was assembled inside the administration building at Atascadero. It was later moved to downtown Los Angeles, where it could be viewed by potential investors in the project.

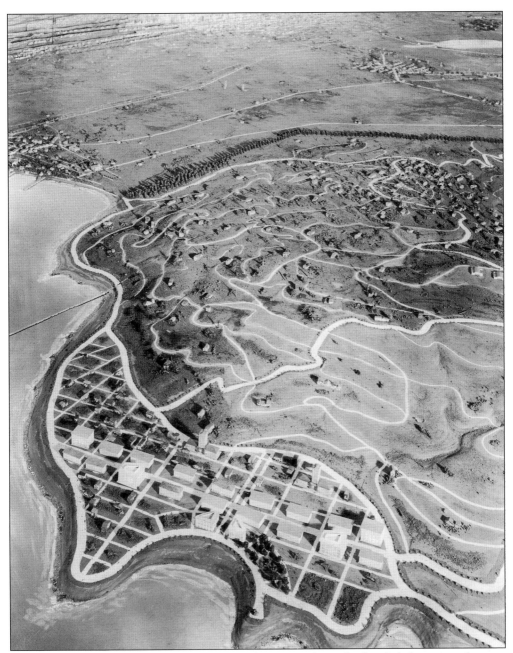

A 1921 close-up of the diorama for the Palos Verdes Project shows the detailed placement of streets, buildings, and parklands. In this scheme, Lunada Bay is laid out on a grid pattern and includes some very large commercial or public structures. Fortunately, this version did not come to pass. In an interview, Howard H. Towle, an early resident and salesman for the project, mentions having seen the model in the Temple Auditorium Building (later known as the Philharmonic Auditorium) in Los Angeles in October 1921. Indeed, a *Los Angeles Times* article from September 1921 mentions that E. G. Lewis had commissioned aerial surveys for the model, which was to be built in Atascadero. Later it was announced that the model was available for viewing between 10 a.m. and 10 p.m. at its new location, the developer's offices at 929 South Broadway in Los Angeles.

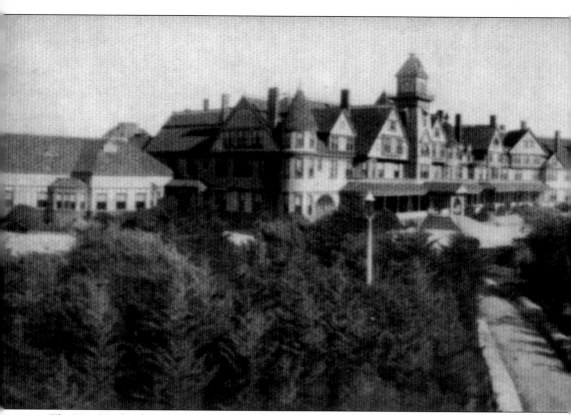

The Hotel Redondo was a favorite of tourists and a casual escape from the heat for many Pasadena socialites. Being the first port in Los Angeles, Redondo was bustling with trade shipping as well as vacationers. Railways brought visitors, as did steamships. The development of the port at San Pedro, coupled with the Prohibition days of the early 1920s, spelled disaster for the hotel. A 1922 *Los Angeles Times* article reported that the hotel was purchased by the City of Redondo Beach and renovated for the use of the Palos Verdes Project as headquarters for its construction

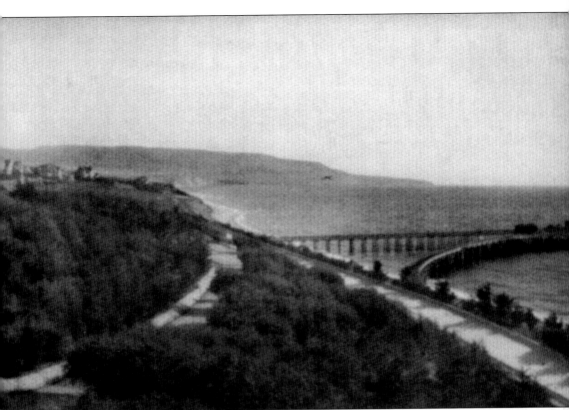

and engineering staff. According to E. G. Lewis, the hotel was to be leased to the Palos Verdes Project for three years at the rate of $1 per year and would include offices for 150 draftsmen and 150 surveyors. The Art Jury's minutes from the 1920s indicate that they met there for a time, and it was used as offices for the *Palos Verdes Bulletin* until the Gardner Building was completed in Malaga Cove Plaza. The Hotel was closed in 1925, dismantled, and sold for the value of its scrap lumber, a mere $300.

COMMONWEALTH TRUST COMPANY

Certificate No. 152

$1000.00 ✓

NON-CONVERTIBLE
CERTIFICATE BENEFICIAL INTEREST
PALOS VERDES TRUST

COMMONWEALTH TRUST COMPANY hereby certifies that _Anna M. Larson_____

1410 Justine St.

appears on its records as the registered owner of a non-convertible beneficial interest in Palos Verdes Trust, so-called, in an amount of

COMMONWEALTH TR. CO. $1000 AND 00 CIS _____Dollars ($1000.00____) as the said

non-convertible interest is defined and set forth in and according to the terms and conditions of that certain trust indenture executed by E. G. LEWIS as Trustor, and TITLE INSURANCE & TRUST COMPANY as trustee, and as subsequently amended and modified and accepted and declared by the said COMMONWEALTH TRUST COMPANY as trustee.

According to the terms and conditions of said trust indenture, the registered owner of said non-convertible beneficial interest will be entitled to payment out of the proceeds of the assets of the Palos Verdes Trust, so called, applicable to the payment of non-convertible certificates, from time to time, when funds are available for that purpose. The registered owner of this certificate shall be entitled to have and receive only such part of the proceeds of all of the remaining assets, applicable to the payment of non-convertible certificates together with such part of ninety (90) per cent of the net profits of the said project as the principal amount of this certificate bears to the total principal amount of all registered non-convertible certificates and registered subscriptions therefor not then in default, outstanding at the time, when and as provided in said trust indenture, and the amendments and modifications thereof.

This certificate is given by the trustee in accordance with the terms and provisions of Section 5, Article 2, of said trust indenture, and shall be in lieu of the non-convertible note provided for in Section 2, Article 2, of said trust indenture, and shall be secured by and be subject to all the terms and provisions of said trust indenture and all amendments and modifications thereof, securing this and other convertible and non-convertible certificates, and registered subscriptions therefor, only when certified and registered by COMMONWEALTH TRUST COMPANY, Trustee, at its office in the City of Los Angeles, California. This certificate is transferable only by surrender to and re-registration by the Trustee in the name of the transferee.

The holder hereof by the acceptance of this Certificate agrees to and becomes bound by all the terms and conditions of said trust indenture as amended and modified and accepted and declared by Commonwealth Trust Company, as trustee, and of this Certificate.

DATED Los Angeles, California, this____30th____ day of ____August____, 192.3.

COMMONWEALTH TRUST COMPANY, Trustee,

By _____
President.

IN view of the E. G. Lewis Bankruptcy proceedings and in fairness to all those who are in any way interested, financially or otherwise, in the development of Palos Verdes, we wish to state that all connections, interests and associations between Mr. Lewis and the Palos Verdes Estates were severed February 23, 1923. Ownership of Palos Verdes is vested solely in its 4000 underwriters and is free and clear of all encumbrances whatsoever, and can in no way be affected by Mr. Lewis' affairs.

This certificate of the Commonwealth Trust Company was issued in 1923, representing $1,000 of the $1 million that was salvaged after the board of the original Title Insurance and Trust Company voted to pull out of the project and return all funds received on the subscription notes. The Commonwealth Trust Company was merged into the Bank of America on September 28, 1923. (Courtesy of Susan Nelson.)

The back side of a promotional pamphlet for Palos Verdes Estates is depicted. Naturally, with the bankruptcy and legal proceedings against E. G. Lewis, the new management of the project wanted to distance itself from him as quickly as possible and reassure the 4,000 underwriters that their investment was safe. This is not surprising, as throughout the mid- to late 1920s Lewis was ripped in the press for his financial shenanigans.

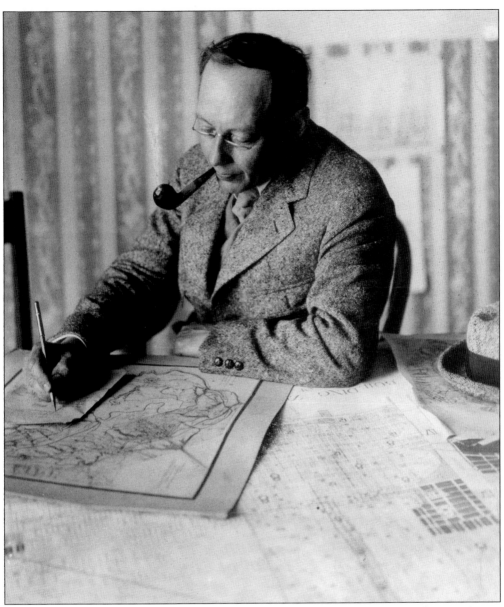

Frederick Law Olmsted Jr. is seen in a photograph from 1925. Soon after acquiring the 16,000 acres of the peninsula, Vanderlip contacted the Olmsted Brothers landscape design firm of Brookline, Massachusetts (sons of Frederick Law Olmsted Sr., codesigner of New York's Central Park). Vanderlip had selected the Olmsted Brothers to design the grounds for an 18-acre subdivision beside Beechwood, his 147-acre family estate at Scarborough-on-the-Hudson, New York. John C. Olmsted, stepbrother of Frederick Law Olmsted Jr., took the lead on the project initially, but progress was interrupted by the events of World War I. Frederick Law Olmsted Jr. joined the war effort, but John had physical ailments that prevented him from enlisting and eventually led to his demise in 1920. With the project recommencing under the direction of E. G. Lewis in 1921, Frederick Law Olmsted Jr. took control of the Olmsted Brothers firm and carried on with the work at Palos Verdes. He was instrumental in drafting the far reaching protective restrictions that would shape the city of Palos Verdes Estates.

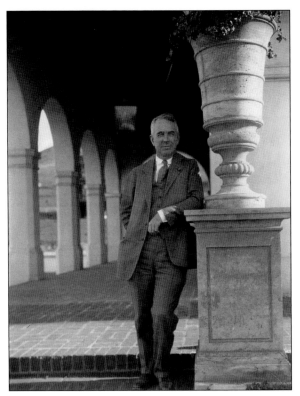

James Frederick Dawson (portrait taken in 1926) was a landscape architect with the Olmsted Brothers, beginning in 1896. It was Dawson who was first contacted by Frank A. Vanderlip in December 1913 regarding the development of the Palos Verdes Ranch. Dawson in turn contacted John C. Olmsted, who was the head of the Olmsted Brothers firm at the time. Dawson would remain involved in the Palos Verdes Project until the time of his death in 1941.

George Gibbs Jr., pictured here in 1927, worked as a landscape architect for the Olmsted Brothers from 1905 to 1914 and again from 1923 to 1933. He was chairman of the Park and Recreation Board of the Palos Verdes Homes Association and was one of the earliest residents, building his home on Via Campesina in 1925. He was involved in the tragic December 1928 automobile accident that claimed the life of coworker and friend Farnham B. Martin.

Roads and plantings were laid out by the Olmsted Brothers. An abundance of flowers was placed along the main thoroughfares and in the plazas. This eastward view from 1925 toward the Palos Verdes golf course shows the developing landscaping along a section of Granvia La Costa, which later became Palos Verdes Drive West.

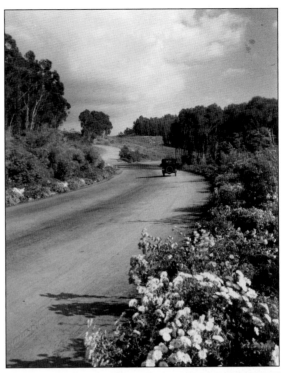

The north entrance to the city of Palos Verdes Estates is seen looking south on January 7, 1927. The Olmsted firm paid special attention to this main entrance to the city coming from Redondo Beach and Torrance with its manicured walking paths and flower beds. Scenes like this were often used in promotional materials for the project.

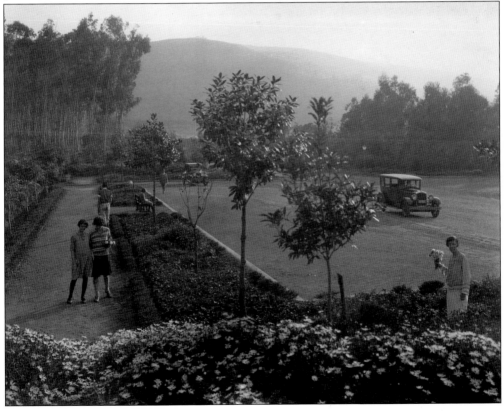

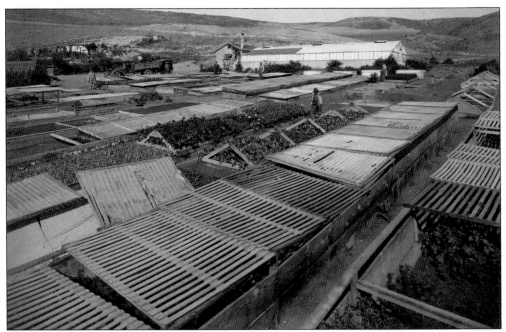

The Palos Verdes Project Nursery at Lunada Bay is depicted in 1925. According to a *Los Angeles Times* article, Frank Vanderlip had established an initial nursery as early as October 1914 at Portuguese Bend under the direction of the Olmsted Brothers. The nursery at Lunada Bay was developed when the Palos Verdes Project picked up steam after World War I.

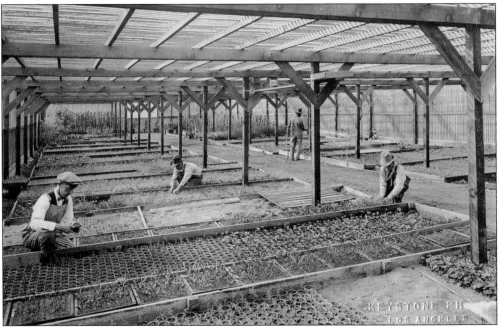

Workers tend to the seedlings in 1925 at the project nursery. The nursery was established to encourage planting on the lots that would soon be built upon. Hundreds of thousands of trees were propagated in the nursery, and ornamental shrubs and plants were made available at cost to "bona fide" owners of Palos Verdes lots.

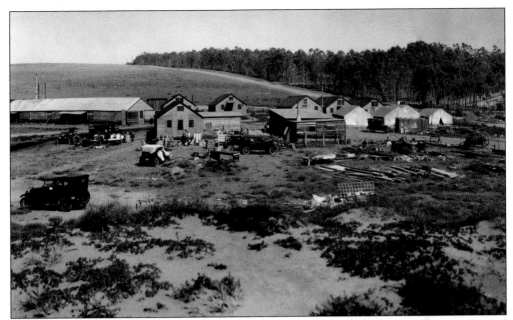

The Mexican Camp at Malaga Cove is seen in 1923. The tents and small wood structures housed some of the laborers who worked on construction of the roads. Judging by its relationship to the eucalyptus groves along the northern border of the city, it appears that the camp was in the vicinity of the Palos Verdes golf course. By 1927, approximately 70 miles of roads had been graded, subsurfaced, or paved.

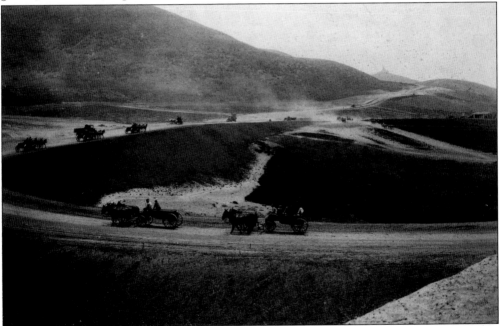

Many teams of mules, pulling "drags" or "Fresnos," were utilized to move a massive amount of land in order to build up the roads. This 1924 image looks across Malaga Canyon to where eventually the Malaga Cove Plaza would be built. Way off in the distance, perched atop a barren knoll, is the recently completed Clubhouse 764, or La Venta Inn, as it was ultimately known.

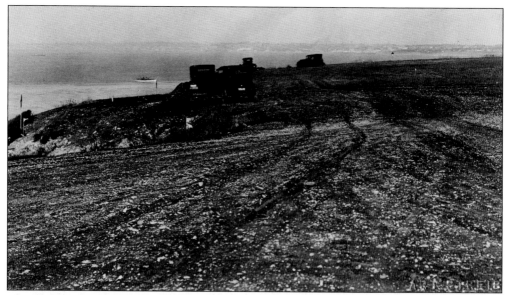

The developers of Palos Verdes were faced with some monumental engineering tasks. Prior to 1925, the main roads into the peninsula from Los Angeles were Western Avenue and Hawthorne Boulevard. The old ranch road that wound around from Malaga Cove toward Lunada Bay was graded at 18 percent near Bluff Cove due to the sheer 420-foot cliff, the highest on the West Coast. In order to continue the coast road, then known as Granvia La Costa (Palos Verdes Drive West now), it was necessary to move 300,000 cubic yards of dirt and rock, which was accomplished with steam shovels, a rock crusher, and ultimately 60 tons of blasting powder. The image above is from 1925, prior to the blast; below, a steam shovel is at work in 1925.

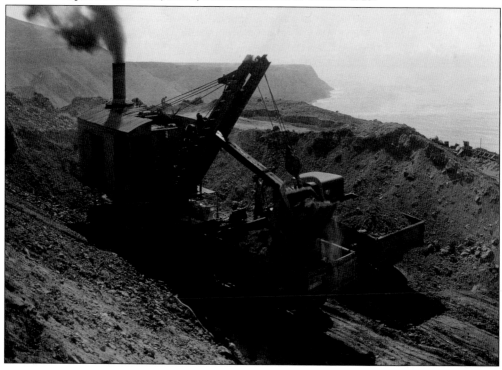

Above, this 1924 image shows the Bluff Cove prior to the Douglas Cut blast, so called because of the cement surveyor's monument labeled "Douglas," which had been placed at the highest elevation of the bluff at the time the streets were laid out. The blast cleared the way for the coast road to go through, bypassing the steep grade of the Zenith Road and shortening the commute around the peninsula by almost 2 miles. Below is an image of the exact moment of the Douglas Cut blast on October 17, 1924. According to the *California Illustrated Review*, it was estimated that over 50,000 people came to watch the blast and some 6,000 vehicles were parked along the cliffs.

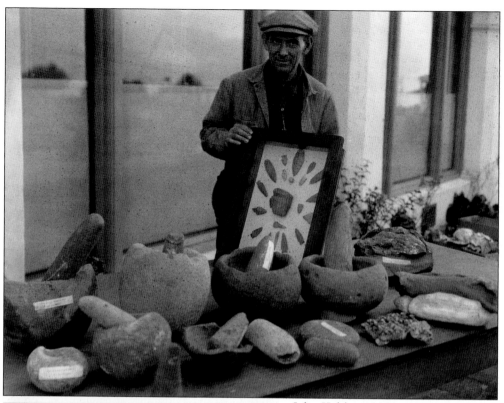

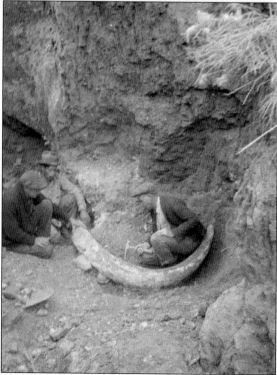

John Kohler, a Valmonte resident, was photographed April 3, 1926, with a display of Native American artifacts in front of the Gardner Building in Malaga Cove Plaza. Jay Lawyer, general manager of the project at the time, appealed to any residents or persons connected to the project who discovered any artifacts or fossils to turn them in to Kohler for further study and display at Malaga Cove School.

In April 1927, some Malaga Cove School children discovered an 8-foot-long Imperial Elephant or Mammoth tusk and reported it to the engineering department of the project. Recent rains had exposed it embedded in a cliff near the school. It was estimated the animal it came from weighed at least three tons. The object was mounted and displayed in the sales office at Malaga Cove.

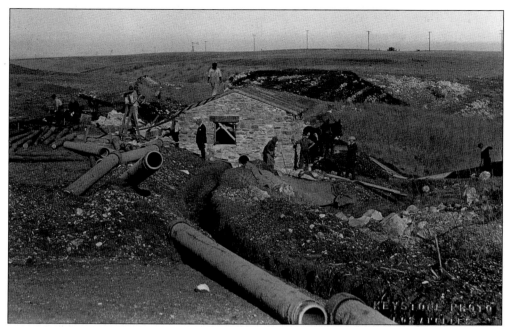

Pump house No. 4 at the Palos Verdes Golf Course is pictured in an undated photo, around 1924. Large diameter pipes are being laid into trenches with several workers, mules, and some men overlooking the operations. Clarence E. Howard was the architect for the Golf Club Clubhouse and its outbuildings.

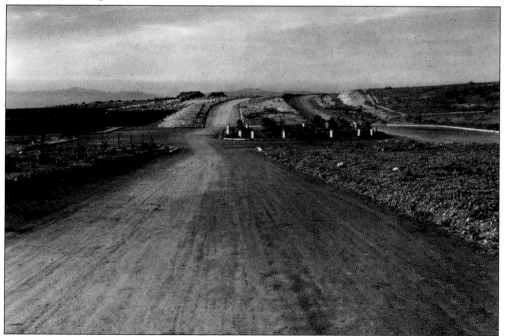

By February 18, 1926, the date of this image, many of the main roads had been graded but remained unpaved. This view to the northeast shows the Lunada Bay Plaza area with the recently landscaped traffic circle at the intersection of Granvia La Costa (later, Palos Verdes Drive West) and Yarmouth Road.

By the middle of the 1920s, Palos Verdes Estates was well on its way to meeting or exceeding the greatness imagined by its early investors and developers. A highly acclaimed design by the Olmsted Brothers was materializing, many roads were in place, several homes were completed, La Venta Inn and the golf club were in heavy use, Malaga Cove Plaza was beginning to take shape, and grander plans were on the horizon. The image at left, depicts the Malaga Cove Plaza ready for development around 1924. Below, the open roads and still bare hills wait to be claimed in an image dated August 7, 1925.

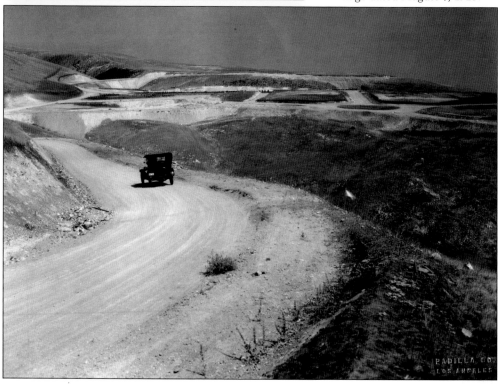

Two

LA VENTA
SELLING THE DREAM

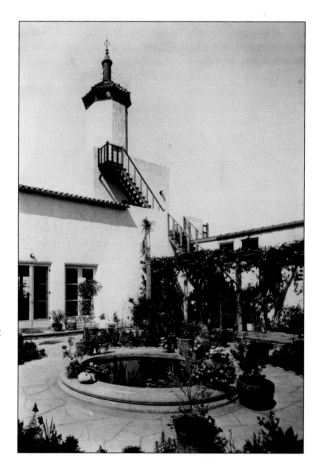

The courtyard of La Venta Inn is seen in October 1927. Originally called Clubhouse 764, it was the first permanent building constructed by the Palos Verdes Project. Designed by the Davis brothers (Walter Swindell and Francis Pierpont) and built in 1923, it was used to attract and entertain realtors and potential land buyers and was used for meetings by members of the project.

On June 17, 1923, E. G. Lewis held a massive real estate rally at Malaga Cove, near the present location of Malaga Cove School. The two men pictured here seem to be "checking in" visitors, no doubt for the purpose of counting attendees and also to build up the already massive mailing lists, which Lewis used to market his fantastic array of investment opportunities.

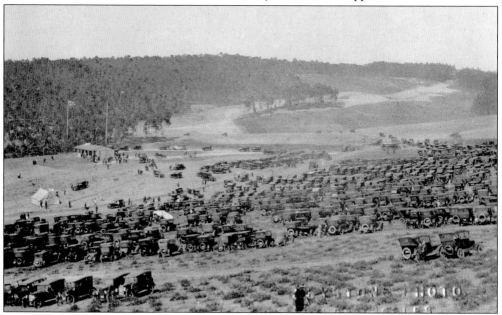

Seen here are some of the 5,000 automobiles, according to *The California Illustrated Review*, that arrived for the festivities at the rally. There were yacht races visible from the bluffs, stunt flying, foot races, and exhibitions of Spanish dancing, along with free coffee and lunch. If Lewis's account of the event is to be believed, 35,000 people attended the rally.

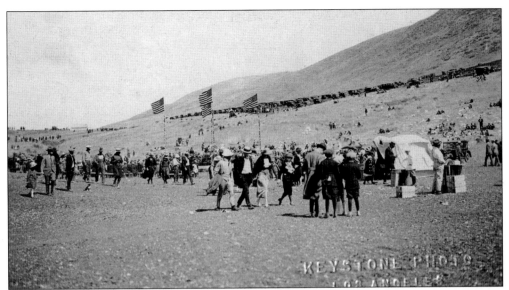

This is a portion of the crowd that attended the real estate rally in Malaga Cove. According to a *Los Angeles Times* article covering the "Fiesta," there were to be no sales of property that day, only festivities and enlightenment. Over 100 staffers were on hand to welcome the curious guests. The *Times* article quotes Henry Clarke, sales director, as commenting that the vast tract of land had had only six owners since the initial grant by the King of Spain.

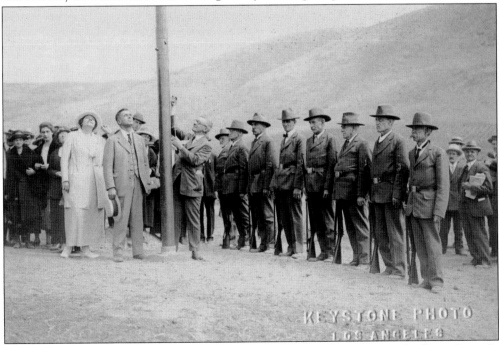

A photograph from the June 1923 real estate rally shows E. G. Lewis raising the flag as his wife, Mabel, and J. H. Coverley, general manager of the Palos Verdes Project and vice president of the Title Insurance and Trust Company, look on. The Hollywood American Legion Band played "The Star Spangled Banner." Standing at attention are eight uniformed veterans of the Grand Army of the Republic, who fired a salute.

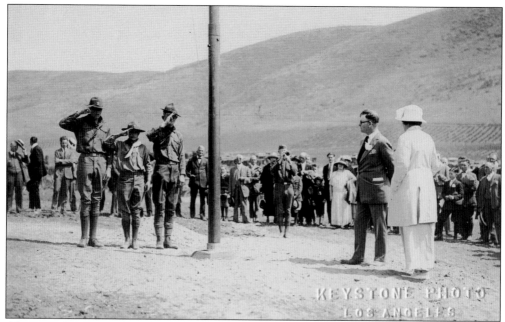

Above, at the real estate rally of June 1923, three Bay District Boy Scouts are opening the day's events with a flag-raising ceremony. The scouts salute the flag as E. G. and Mabel Lewis stand by. Below, a photo op captures some key figures involved in the Palos Verdes Project: (from left to right) E. G. Lewis, trustor; J. H. Coverley, general manager; Mabel Lewis, ladies interests; Henry Clarke, sales manager; and Col. John C. Low, chief of engineering staff and later president of the Palos Verdes Homes Association. There were often changes in responsibilities among individuals involved in the project and some carried multiple titles.

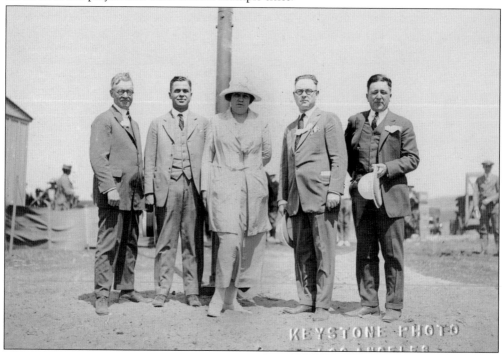

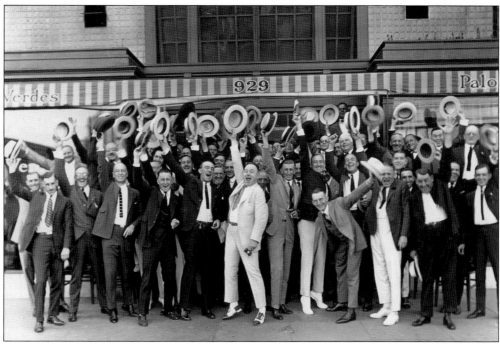

A jubilant group of Palos Verdes sales staff members in January 1923 is standing in front of the staff headquarters located at 929 South Broadway in downtown Los Angeles. A handwritten note on the back of the photograph explains the reason for their joy: they had just sold $15,000 worth of underwriting notes.

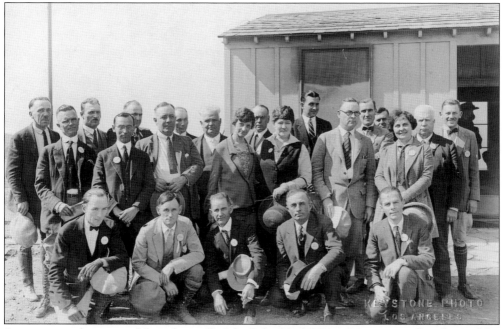

Some men and women of the sales staff of the Palos Verdes Project are pictured in front of the sales office in Malaga Cove, 1925. Standing, holding his hat in the second row is Henry Clarke, sales manager, and to his immediate right is Lucy Koontz, an early salesperson.

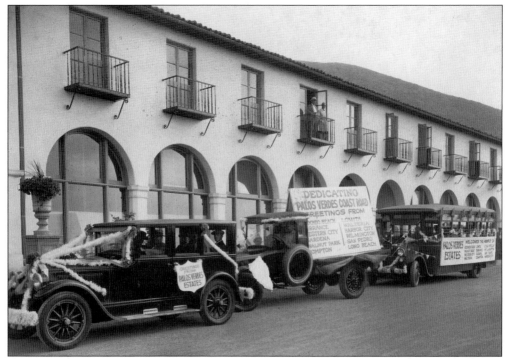

July 31, 1926, offered another marketing opportunity for the Palos Verdes Project with the dedication of the new coast road, which was finished on July 4, 1926. The road connected Western Avenue on the east side of the peninsula with Granvia La Costa at the southern border of the Palos Verdes Estates. The *Palos Verdes Bulletin* claimed 1500 cars per hour had used the road one winter day. Above are some decorated automobiles, part of the 300-car caravan that began in San Pedro and ended at the city park in Redondo Beach, where local officials congratulated each other on the accomplishment. Below, the caravan snakes through the Miraleste section of what became Rancho Palos Verdes.

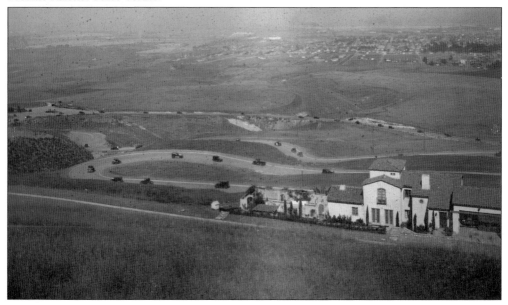

This photograph, dated June 19, 1926, shows the Palos Verdes sales office located in Malaga Cove. Lucy Koontz was salesperson for the Palos Verdes Project under the direction of Henry Clarke. Koontz is known to have sold lots in the area below La Venta Inn called Cincinnati Hill.

Henry Clarke is depicted in a portrait from 1925. Clarke was involved with the Palos Verdes Project from the beginning, being one of the team members assembled by E. G. Lewis in 1921–1922. Late in 1925, as announced in the *Palos Verdes Bulletin*, he would resign, to be replaced by Donald K. Lawyer.

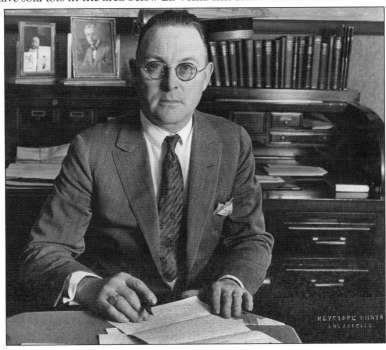

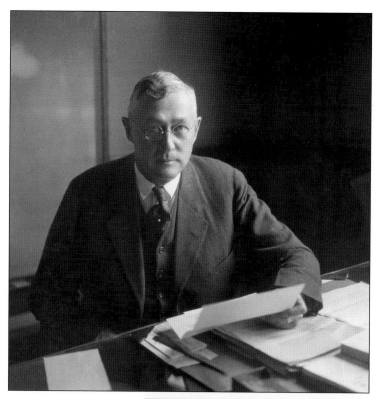

A portrait of Jay Lawyer is dated October 9, 1926. Lawyer, general manager for the Palos Verdes Project, became involved as a representative of Vanderlip's syndicate as early as 1914. He met Frank Vanderlip in Spokane, Washington, while working on a subdivision there. Although not a homeowner in Palos Verdes Estates, he and his wife, Margaret, were active in the community. He stuck with the project during some tough years, resigning in 1932.

Donald K. Lawyer is seen in a portrait dated October 9, 1926. Donald, who was the son of Jay Lawyer, took the position of sales manager following the departure of Henry Clarke in 1925. In 1926, Donald built his home in the Margate district, located at 909 Via Coronel, designed and built by John Byers, an important figure in the Spanish Colonial Revival architectural style who favored the Mexican and Spanish roots of native California architecture.

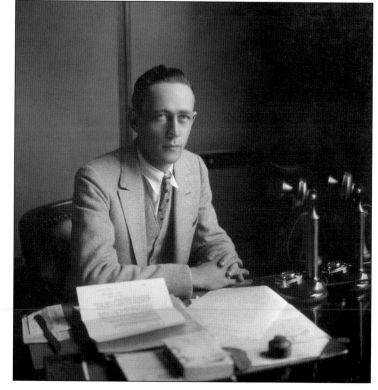

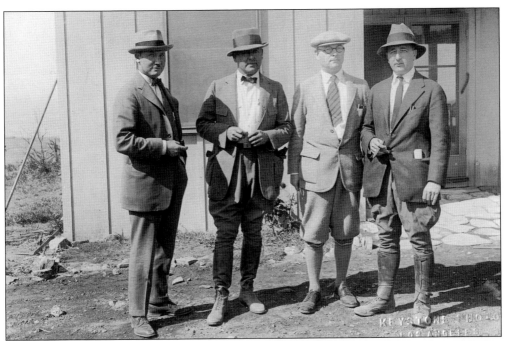

This image from June 1925 features four businessmen in front of the Palos Verdes sales office. Pictured from left to right are unidentified, Eulogio J. "Jack" Carrillo (early resident, engineer for Shattuck and Eddinger Construction Company, and brother of famous movie actor, Leo Carrillo), Henry Clarke (project sales manager), and Col. John C. Low. Low's home at 521 Granvia La Costa in Malaga Cove was built in 1924.

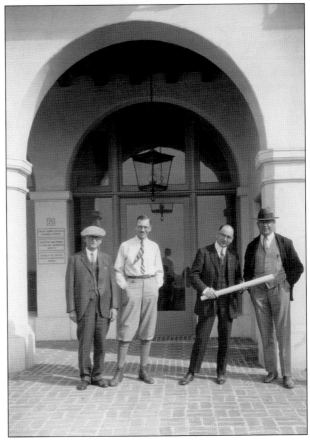

On June 4, 1926, this image captured the front of the recently dedicated Gardner Building, or "Casa Primera" as it was supposed to be known. From left to right are R. E. Brownell (engineer for the Palos Verdes Project and general manager of the Palos Verdes Water Company), Karl Lloyd (engineer), Edgar L. Etter (purchasing agent for the project and first postmaster of Palos Verdes Estates), and Laurence Hussey (chief engineer).

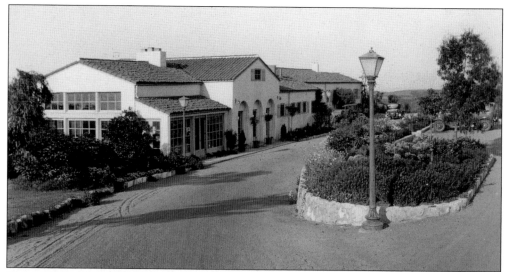

The south facade of the Palos Verdes Golf Club is seen on November 28, 1926. The Golf Club clubhouse, built in 1924, is located at the south end of the golf course. The course itself lies between the Valmonte and Malaga Cove neighborhoods. It was utilized almost immediately for attracting and entertaining potential lot buyers, developers, and real estate people.

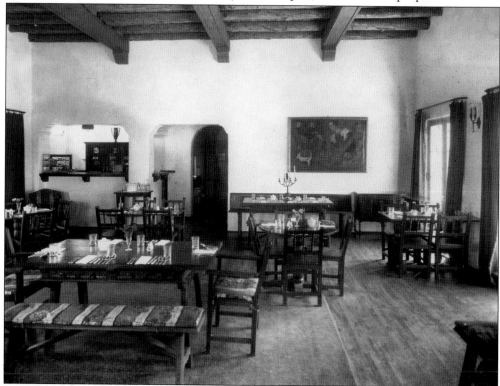

An interior view of the Palos Verdes Golf Club clubhouse is seen in June 1925. The two-story, 11-room clubhouse designed by Clarence E. Howard in collaboration with Art Jury members David Allison, Robert Farquhar, and Myron Hunt featured colonnaded walks, open beam ceilings, red tile roofs, and Spanish motifs. The furniture and drapes were by Barker Brothers of Los Angeles.

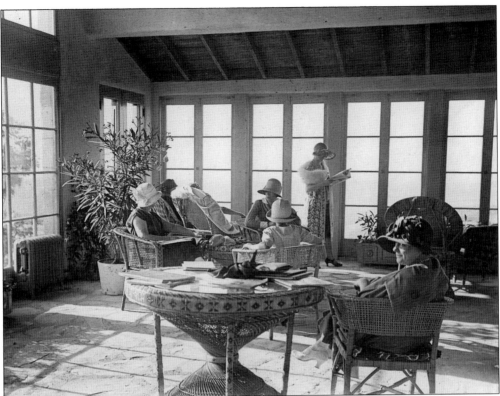

In March 1925, some ladies relax in the sun parlor (added in 1925) of the Palos Verdes Golf Club clubhouse. The room featured flagstone floors, many French doors, and wicker furniture. Ferns and tropical plants adorned the walls and hung from the ceiling. It was not long before it became a regular meeting place for women of the community.

March 4, 1929, is captured at the Palos Verdes Golf Club. A project dinner presided over by Jay Lawyer was prepared by newly appointed club manager W. F. Koehler for 86 employees of the Palos Verdes Project. The stated purpose of the dinner was for the project members to get to know each other better. There were several short talks.

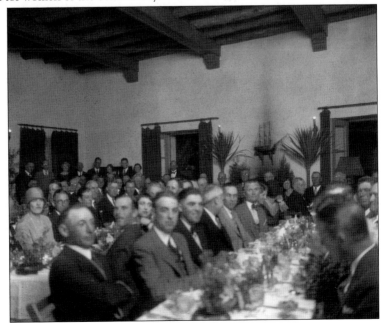

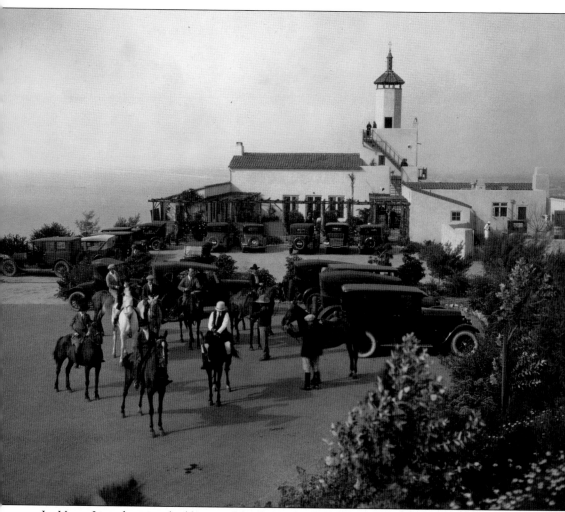

La Venta Inn, photographed here on March 21, 1926, has been used for many purposes over the years, promotion and sales of Palos Verdes Estates real estate being chief among them. Sometime around 1924, it was decided that Clubhouse 764 would be called La Venta, which in Spanish dialect meant a small roadside inn or *posada*. However, it also translated into "The Sale" in Spanish, and there could not have been a more fitting name. From the mid- to late 1920s, a steady stream of visitors came from every corner of the country and the globe. The Notes from La Venta Inn column of the *Palos Verdes Bulletin* chronicles the steady parade of guests entertained there. Some were convinced to buy, as evidenced by subsequent lot sales to the same guests. A few places from which visitors travelled in a one-year period alone included Arizona, New Hampshire, Maryland, Florida, Alaska, Texas, Washington, D. C., Colorado, Connecticut, Louisiana, New York, Vermont, Utah, Oregon, Minnesota, Montana, Georgia, Massachusetts, Nebraska, Tennessee, Michigan, Hawaii, Illinois, Switzerland, Norway, England, Italy, France, Japan, China, Mexico, Russia, Egypt, India, and Brazil.

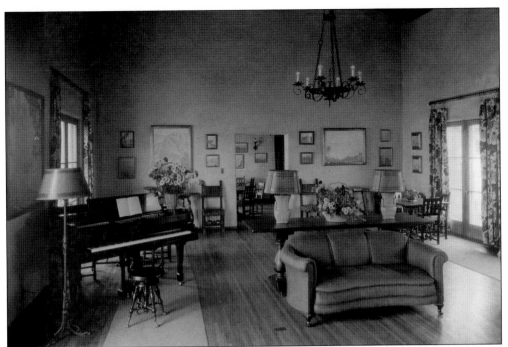

A 1926 interior view depicts the elegant lounge at La Venta Inn. The relative isolation of the Inn may have served as an attraction of sorts, as during the 1930s, the inn was used as a weekend retreat by many Hollywood celebrities and other luminaries such as Charlie Chaplin, Rosalind Russell, Greta Garbo, Cary Grant, Charles Lindbergh, Errol Flynn, Betty Grable, Bob Hope, Gloria Swanson, and Tyrone Power. The inn also gained popularity with high ranking military officers and their wives.

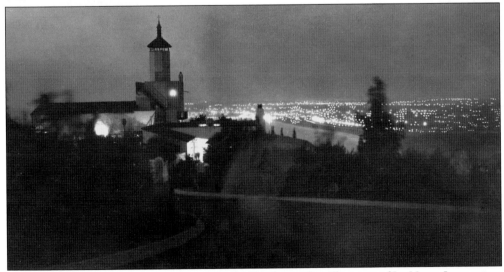

An image taken on a clear evening in April 1928 shows the silhouette of La Venta Inn against the bright lights of Redondo Beach in the distance. With its commanding view across the Santa Monica Bay high on the hills above Malaga Cove, the inn was an obvious choice in 1942 for the central observation post of the coastal artillery, who ultimately installed gun emplacements along the bluffs of the peninsula in the uncertain days leading up to World War II.

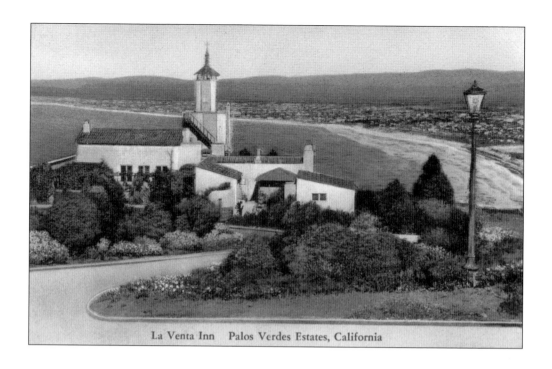

La Venta Inn Palos Verdes Estates, California

Postcards like these four, many using photographs by project photographer Julius Padilla, were mass-produced to promote the project and could be purchased from the drugstore located in Casa Primera at Malaga Cove Plaza. There were dozens of different views of natural landscapes and Palos Verdes landmarks as they developed. Many featured La Venta Inn and views of Malaga Cove

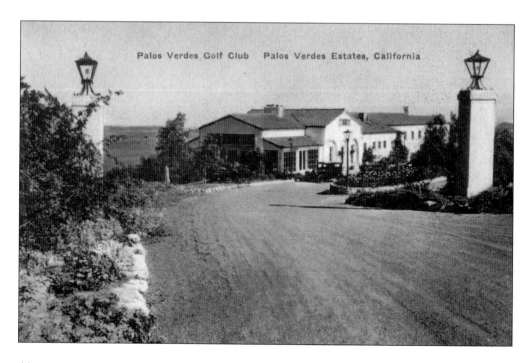

Palos Verdes Golf Club Palos Verdes Estates, California

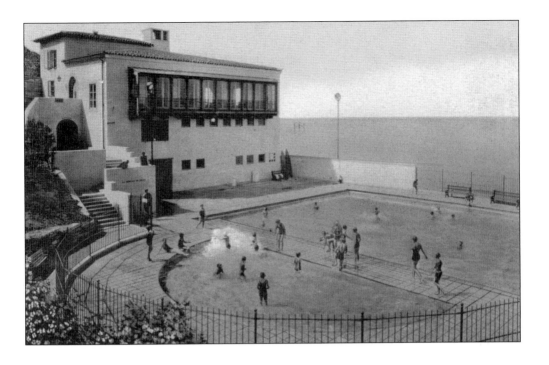

Shown here are the plaza and the golf and beach clubs, as well as some of the early residences. Most of the postcards have been colorized and present a very appealing impression of the early days of Palos Verdes Estates. (All, courtesy of Susan Nelson.)

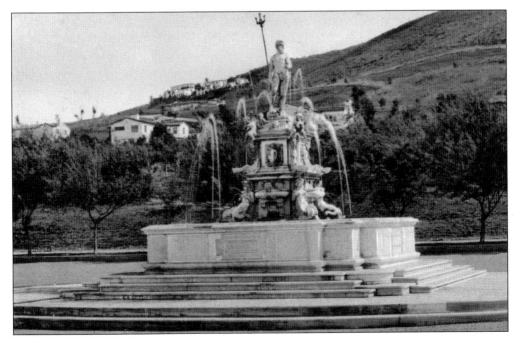

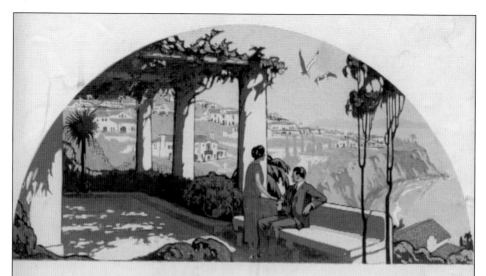

THE RIVIERA OF AMERICA

Where Beauty Wins over Commercialism

UPPOSING a Fairy Godmother suddenly appeared on your doorstep and offered to take you to the Riviera—in the south of France—for the day. Would you go? Of course you would. The Riviera has always stood in your mind as the very finest residential district in the world.

You would immediately accept the fairy invitation. But—instead of your having to go all the way to Europe you are told that the Riviera has been brought to California—just a few miles from your home. Wonderful!

And so it is. In location, in coast line, in climate, and in its exact position on the Pacific, Palos Verdes is a physical duplicate of the French Riviera overlooking the city of Nice.

Why is it that the world's finest residential communities—such places as the Riviera—Riverside Drive, New York—St Francis Wood, San Francisco—Montecito, Santa Barbara, have been able to retain their natural beauty in spite of growth and expansion?

It is because they have done what Palos Verdes is doing. They have made artistic development a thing of greater importance than mere commercial growth.

Scenery, location, a beautiful coast line, are Nature's own gifts. It is left to those who plan and build and live in such places to retain beauty or to destroy it. To make it the place of artistic homes, gardens, parks or give it over to unsightly shacks, beach buildings and so called amusement grounds—common to many of our beach cities. Palos Verdes will always retain its naturally attractive features. Its Protective Restrictions will insure a beautiful city—the logical centre of culture and refinement.

Already over 3000 men and women have purchased homesites on its terraced slopes, and will there enjoy life on a higher plane, in better health and greater happiness. Why do you delay your selection? Why not drive down today and get the true spirit of Palos Verdes. See what is being done. Compare the prices. See what you get for what you pay.

Palos Verdes prices are low—from $2000 to $6000 and up.

After the departure of E. G. Lewis, the new project team refined and continued the advertising campaign. This full page color advertisement, and many like it, was featured in the June 1924 edition of *California Southland* magazine, a publication dedicated to the promotion of architecture, art, and lifestyle. It was one of a series romanticizing the Palos Verdes Estates. Both Frank Vanderlip and E. G. Lewis had envisioned the peninsula as a Riviera of the Pacific, the former having commented upon his first visit that it reminded him of Italy's Sorrentine Peninsula and the Amalfi drive. In typical fashion, Lewis goes a bit further, speculating that Palos Verdes would be to Los Angeles what the Acropolis was to Athens, predicting that Palos Verdes Estates would be the most superb residential district ever created and that it would surely become the seat of art, culture, learning, and highest residential architecture in all California. Most of the promotional material for the project of the 1920s touted the protective restrictions that were put in place to protect the natural beauty in perpetuity. (Author's collection.)

From Painting by J. D. Johns

To a Certain Father in Los Angeles

AN'T you remember the pirate ships you used to sail—the treasure lands—the secret paths—the lookout in the old gnarled tree—those fragrant boyhood dreams so precious now?

Is that lad of yours—that boy who bears your name—to have such dreams? Does he know the joy of a cave, with deep and winding passages? Has he camped on an Indian trail with signs 'o redskins all about, and dined sumptuously on delicious black-burned "taters" hot from the ashes? Or are his memories to be cluttered with emotional sex movies, concrete backyards, lawns not made for somersaults and streets that are danger lanes of traffic?

Would you trade *your* memories for his stone backyard where the only campfire is the belching rubbish incinerator

Give your boy his dreams—his playright to the lands of adventure. Take him today, with the wife, and little "sister" too, to Palos Verdes and let him catch for an hour or two the joy that might be his. For in this New City every boy is King and his courtiers are the ships that sail by, the deep running canyons, the rolling hillsides, the open skies and long vistas of purple moun-tains. Here your boy—your girl—may have his playright and memories as golden as those you hold so precious.

❧　　❧　　❧　　❧　　❧

Many things belong to the land of boyhood over which you may never again have proprietorship. But every man sooner or later realizes that unless the best values of life are to escape him utterly he must place between himself and the hurly-burly of these times a plot of ground, a garden wall and perhaps a tree or two.

In Palos Verdes—the New City—you and your family have opportunity for free and spacious living, on a scale probably never before attempted in this country and at a cost far under what you may expect. Many home-estates, with the blue ocean before them—where your boy and girl may be King and Queen of a great domain—are priced far less than you would expect.

And, you may live here on your own home-estate for a reasonable payment down, with the balance conveniently spread over three years. Drive the family to Palos Verdes for all day. Picnic where you like. You'll find a hundred places where you would like to build a home.

This advertisement was featured in the March 1924 edition of *California Southland* magazine. A series of romantic and evocative lifestyle images and vividly colored architectural renderings flowed forth from the creative imaginations of the staff throughout the 1920s. The ambitious promotion of the Palos Verdes Estates did not slow in the post-Lewis era, but there was a more polished, classy feel to some of the sales materials once Donald K. Lawyer took over the sales management position from Henry Clarke in 1925. The advertisement featured here makes no attempt to disguise its statement, that of presenting a wholesome environment ideal for raising children. It is also interesting to note its target, the male head-of-household (who most likely would make the final decision on a real estate purchase). In a press release by Lawyer to the *Los Angeles Times* in December 1925, he tells how a questionnaire answered by 2,000 people indicated that 85 percent of respondents believed that Palos Verdes Estates would be a desirable place to raise children. (Author's collection.)

47

The Cameron residence on Via del Monte, Montemalaga, is seen in January 1925 (Kirtland Cutter, architect). The attractive garden gate with its wrought iron lantern, the pierced stucco window grills, and red tile roof are indicative of the predominant architectural style of the estates designated Type I by the Art Jury as part of the protective deed restrictions of the project. This style was required to be used for buildings located along the coastal bluffs but was allowed in other districts.

The Nicholas Bleeker residence, located on Via Campesina in Malaga Cove, is depicted in September 1928. "Nick" Bleeker was a regular at the Palos Verdes Golf Club and participated in many a tournament. Another example of the Type I architectural style, this home was one of two in Palos Verdes Estates designed by Roland E. Coate Sr., who was a principal of the well regarded Los Angeles firm of Johnson, Kaufmann and Coate prior to establishing his own successful practice in 1925.

This picturesque home (image from 1929) is that of William and Agnes Tizard. Designed by Allen K. Ruoff, it is an example of Type III architecture as designated by the Art Jury for the lower Via la Selva area in Malaga Cove. It featured steeper pitched roofs, a marker of the Normandy style. The home is located on Via Anita in the eucalyptus groves, one of the most charming sections of Palos Verdes Estates to this day.

This wonderful design received honorable mention by the Art Jury in 1926. It is the design of J. A. Lord (Winchton Risley consulting architect) and of the Type III style. The Kincaid residence, built in 1926 on Via Conejo, is representative of the great architecture that was being advanced at Palos Verdes Estates and evidence that the protective restrictions and Art Jury were having the desired effect on the aesthetic development of the Estates. The image is from October 1928.

PALOS VERDES BULLETIN

Published by the Palos Verdes Homes Association, Palos Verdes Estates, California

VOLUME 3 JANUARY 1927 NUMBER 1

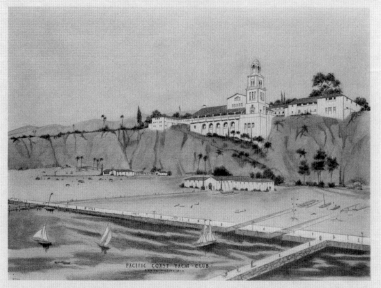

THE PACIFIC COAST YACHT CLUB

A group of prominent yachtsmen of Southern California have recognized the need for a new yacht club, more complete in its facilities than anything yet built on this coast, and having a harbor for pleasure craft whose waters will be safe and clean. They have recently associated themselves in the organization of the "Pacific Coast Yacht Club" and have now made arrangements for a site on the coast of Margate in Palos Verdes Estates, where a beautiful clubhouse is to be built on the top of the bluff and a breakwater extended from the shore to enclose a commodious strip of still water, bounded on the north by Bluff Cove. This site was selected by Mr. Francis B. Smith of San Francisco, a recognized authority on harbor and marine engineering, known throughout the country as "Dry-Dock Smith," who made a careful inspection of the entire coast line from Point Dume to Los Angeles Harbor before recommending this location. His verdict was that a breakwater running northward from the point just south of Bluff Cove, would form, with Flat Rock Point on the north, one of the finest and safest pleasure harbors on the coast—with 66 acres of still water now and an eventual enclosed harbor of some 220 acres in extent.

This site is particularly advantageous, as there are several miles of coast in each direction which will never be used for any undesirable factory, commercial or oil encroachment in the future, to contaminate the water or foul expensive yachts and small craft, and the Clubhouse will be in a permanently high-class neighborhood. Tentative plans for the building are being drawn, showing a very interesting design in Mediterranean style with a tower and a low rambling structure on either side, from which beautiful unobstructed views may be had of regattas and racing events. Passenger and freight elevators will carry people and supplies from

(Continued on page two.)

INSPECTION TRIP TO THE NEW HARBOR
by the Board of Governors on Rex B. Clark's yacht, "Norconian," December 19th, 1926

The January 1927 edition of the *Palos Verdes Bulletin* announced the concept and plans for the development of the ambitious Pacific Coast Yacht Club in the Margate district of Palos Verdes Estates on the bluffs south of Bluff Cove. The site had been recommended by Francis B. "Drydock" Smith, as he was known, for its isolation from any industry that might cause contaminants to soil the waters (and subsequently the expensive yachts). The clubhouse, with its Mediterranean design, featured colonnaded walks and a stately tower overlooking the waterfront promenade and the Pacific beyond. Invitations were sent for lifetime memberships and the first regatta was held April 9, 1927. As late as 1938, according to Art Jury minutes, the project was still being discussed. In the press of the day, it sounded like a foregone conclusion that the Yacht Club would be built. However, like many other grand plans for the peninsula, this did not come to pass.

Three

Nacimiento
The Emergence of a City Sublime

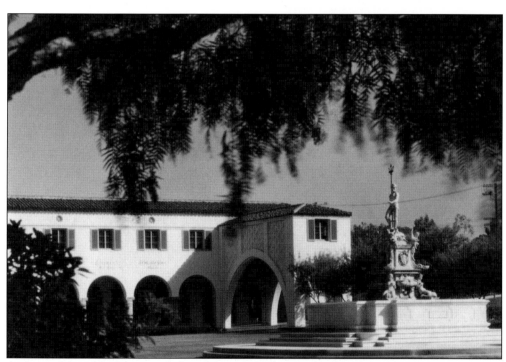

As beautiful and highly regarded as the city of Palos Verdes Estates has become, it is hard to look back at some of the more ambitious, yet largely unrealized plans without a feeling of wistful contemplation. The question has been raised: Has Palos Verdes Estates succeeded in fulfilling the dreams of its founders and designers, and has it upheld the high standards and ideals which were set forth at its conception?

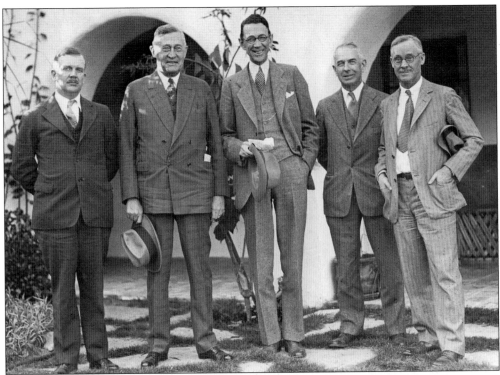

Whatever is said about E. G. Lewis, there can be no dispute that he brought together (to join Frank Vanderlip's recruits) some of the finest men in the fields of city planning, development, and architecture. For this, the members of the community and persons with an interest in fine architecture and city planning should be grateful to Lewis. He appointed the first members of the Art Jury, who were charged with upholding the artistic standards of the Palos Verdes Project. The group first met on November 21, 1922, at the Hotel Redondo. Shown in the rear courtyard of the Gard residence are members of the Art Jury, March 1929. From left to right are Charles H. Cheney (city planner), Jay Lawyer (general manager), David Allison (architect), James F. Dawson (landscape architect), and Robert Farquhar (architect). The Gard residence, designed by Kirtland Cutter, was selected by the Art Jury as the most notable example of residential architecture of 1927.

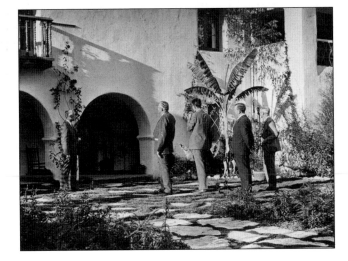

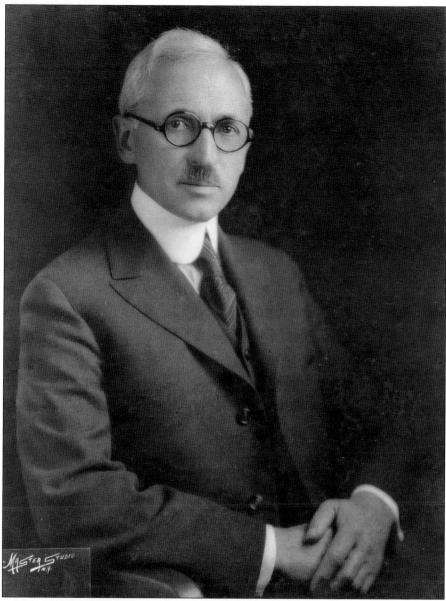

Myron Hunt (1868–1952) was a prominent Pasadena architect who came to Los Angles from Chicago in 1903, where he was involved in the Prairie School movement. Hunt partnered with Elmer Grey, with whom he designed the Mission Inn of Riverside, California, and the Ambassador Hotel of Los Angeles. He went on to design such well known structures as the Rose Bowl, the Huntington Library, and the campuses of Caltech, Pomona, and Occidental Colleges. Hunt was involved in the development of the peninsula beginning in 1914 when he was called upon by Frank Vanderlip to codesign a large country club on the hills above Portuguese Bend. The structure was never built, but he remained interested in the project and rejoined the group led by E. G. Lewis in 1921. Hunt served as president of the Art Jury for many years and was a leader within the American Institute of Architects. The only structures designed by Hunt and his partner, Harold C. Chambers, that saw completion were both in Malaga Cove—the Frederick Law Olmsted Jr. residence on Rosita Place and the Malaga Cove Library.

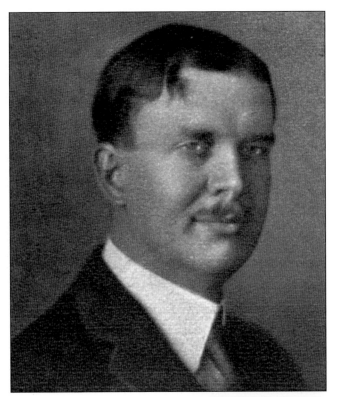

Charles H. Cheney (1884–1943) was a well-respected city planner who, from the 1910s, was associated with E. G. Lewis and his Atascadero development. Cheney was planning consultant for several California cities, among them Rancho Santa Fe, Santa Barbara, Alameda, Monterey, Palo Alto, Long Beach, and Fresno. Once Cheney was involved in the Palos Verdes Project, he dedicated himself to its evolution for the rest of his life.

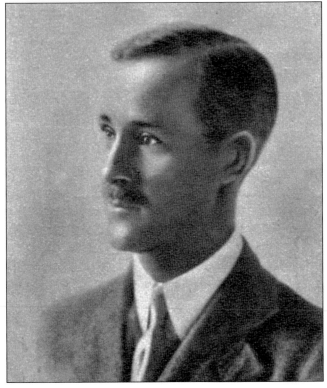

Robert D. Farquhar (1872–1967) was a member of the first Art Jury, assembled in the early 1920s. In 1915, Farquhar served on the Architectural Commission of the Panama-Pacific International Exposition of San Francisco. An award winning fellow of the Southern California chapter of the American Institute of Architects (AIA), he designed the Beverly Hills High School, many fine residences, and also worked with George Edwin Bergstrom on the design of the Pentagon in 1941.

David C. Allison, an Art Jury member from its inception, partnered with his brother James E. Allison, and together they specialized in designing schools and institutional buildings. They accomplished many great works, including Santa Monica High School, The University Club at Los Angeles, and the earliest and most recognized buildings at the University of California at Los Angeles. The iconic Malaga Cove School was their design and earned them an award from the AIA.

Col. John C. Low, another E. G. Lewis recruit and part of the engineering staff, became the first president of the Palos Verdes Homes Association, as well as the Palos Verdes School Board. "Jack," as he was affectionately known, enjoyed the golf course and was often seen in his plus fours. Later he opened a real estate brokerage in Malaga Cove Plaza. He and his family were very active in the community. His home, built in 1924, was one of the first in Palos Verdes Estates.

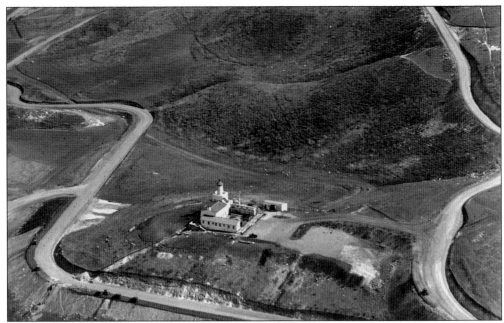

Toward the end of 1923, after the departure of E. G. Lewis, a flurry of activity began. The Art Jury had been meeting regularly and had established its guidelines for the specific types of architecture allowed in each neighborhood and the general principles for submittal of plans for lot owners. On November 19, 1923, the Art Jury held a dinner meeting at La Venta Inn attended by the Art Jury, members of the project, and prominent Los Angeles businessmen such as Henry Huntington, railroad magnate; Harry Chandler, newspaper and real estate giant; and Sumner P. Hunt, renowned architect and fellow of the Southern California AIA. The image above from December 1924 shows the major roads carved into the hillsides and lots ready to be built upon. Below is the pergola in the courtyard of La Venta Inn, 1925.

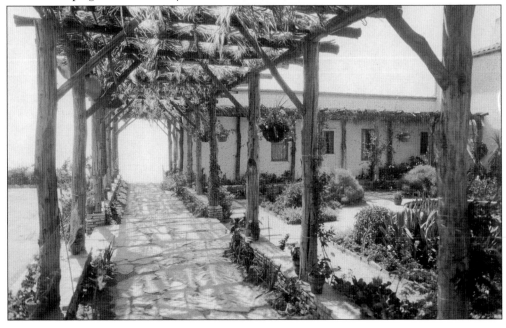

At La Venta Inn in February 1925, a woman admires the view through open French doors leading to a veranda. The inn proved to be in such demand that it was necessary to expand in August 1925. Winchton Risley was chosen as architect for the addition of a private dining room and enlargement of the kitchen facilities and hostess room.

Jay Lawyer (general manager of the Palos Verdes Project) is speaking with Reba Willis, hostess and manager of La Venta Inn for 17 years. For 10 years, starting in 1944, the inn served as a residence for Comdr. Stanley Schnetzler and his wife, Peg. It was reestablished as an inn in 1955 and was designated a historic landmark in 1978.

This view looks north across the front nine holes of the Palos Verdes Golf Course in May 1925. The city of Redondo Beach is visible on the upper right. The 6,108-yard golf course was designed by George C. Thomas Jr. and built by William P. Bell. At the time of its opening on November 15, 1924, all but four holes had ocean views.

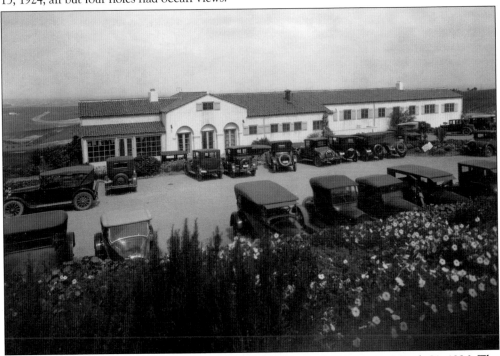

The front entrance to the Palos Verdes Golf Club, facing south, is seen on March 21, 1926. The clubhouse was designed by Clarence E. Howard, with landscaping the design of the Olmsted Brothers. The December 1924 edition of the *Palos Verdes Bulletin* stated that the course had been in use every day since its opening, even during inclement weather.

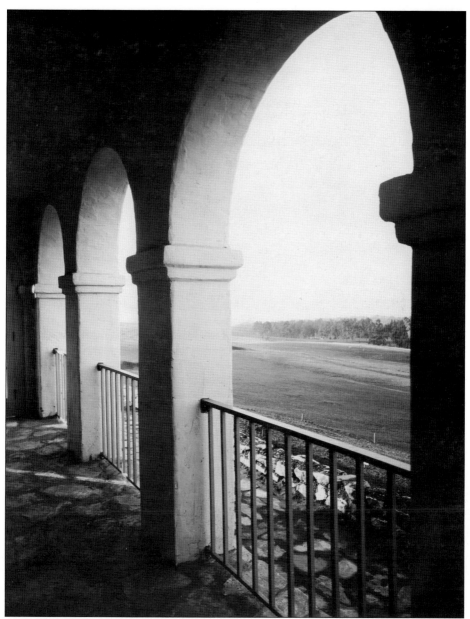

This lovely image, a view of the golf course through the arcaded loggia on the north side of the clubhouse, was captured in January 1925. The wonderful composition of the image is typical of Julius Padilla, the prolific photographer of the Palos Verdes Project who stayed on after being brought in originally by E. G. Lewis. Padilla's work was featured in Lewis's early newsprint advertisement promotions as well as in his *California Illustrated Review.* Following the departure of Lewis, the managers and promoters of Palos Verdes Estates utilized Padilla's skills to great effect in elegant booklets, brochures, and most significantly in the *Palos Verdes Bulletin*, a monthly community newsletter that began in November 1924. The *Bulletin* gave news of current events in the developing community and information on planned building projects and new residents, golf club news, and social happenings. Padilla's photographs documented the growth of the "Estates" with before and after images of homes and neighborhoods showing the maturing landscaping.

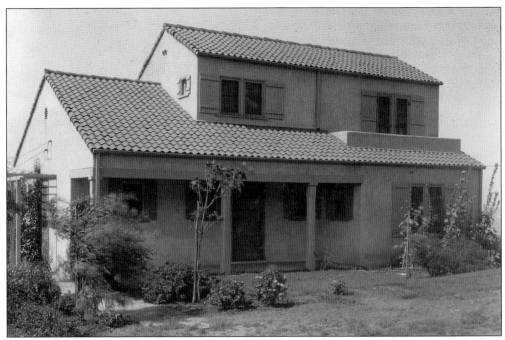

This unpretentious home was the first residence submitted to the Art Jury on August 17, 1923, and after some revisions, the design was accepted two months later. It is one of the first homes completed in Palos Verdes Estates. Built in 1924 and located on Via Montemar in Malaga Cove, the original owner was H. H. Crossman, who was also the builder. It was later sold to H. J. Steinberg.

The Schipkowsky residence at 2616 Via Campesina in Malaga Cove was the recipient of the first building permit issued by Palos Verdes Estates. The home, later owned by Alden L. Hart, was the design of Angus McDonald McSweeney, who was trained by renowned San Francisco architect Willis Jefferson Polk. In this 1925 photograph, the home of Eulogio J. Carrillo is visible on the left.

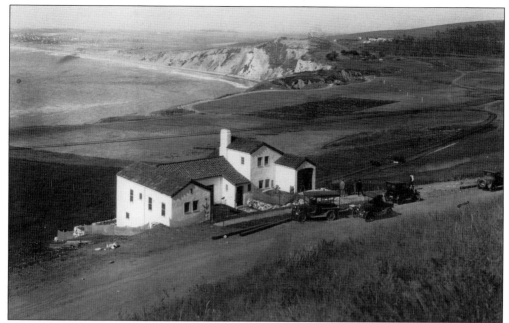

The second home to be permitted in Palos Verdes Estates was that of project member Col. John C. Low. Built in 1924, the year of this photograph, it was the design of John Roth (supervising architect under E. G. Lewis's original team) and a Mr. Parker. Located on Granvia La Costa (later Palos Verdes Drive West), it had a commanding view over the developing lower Malaga Cove neighborhood and the Santa Monica Bay beyond.

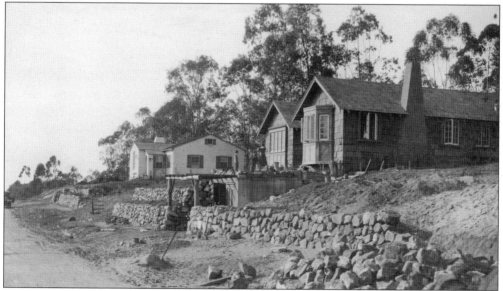

A 1924 image along Via Anita highlights the eucalyptus groves. The home in the foreground was that of Farnham B. Martin, beloved community member. Farnham came to the project with the Olmsted Brothers and became superintendant of parks and planting. Romayne C. Martin was the force behind the establishment of both the school and library. The other home is that of Howard Towle, an early salesperson of the Estates. The designer was Winchton Risley, architect for many early Palos Verdes Estates homes.

Brooks Snelgrove (portrait from June 1926) became building commissioner of Palos Verdes Homes Association in July 1925. Three years earlier, while vacationing on the West Coast from his Wyoming job and home, he happened to notice a truck with the "Palos Verdes Engineering Dept." insignia. Intrigued, he followed it to the Hotel Redondo offices of the project, and a few days later he was hard at work at his drafting table.

The home of Donald K. and Constance Lawyer was under construction on Via Coronel in Margate in 1926. The design received an honorable mention for Best Architecture of 1927 from the Palos Verdes Art Jury. The architect was John Byers, an authority on the Native American and Spanish Mission architecture of New Mexico, Texas, and California. He was a proponent of organic, handmade materials and techniques in his designs and brought craftsmen from Mexico for some of his projects.

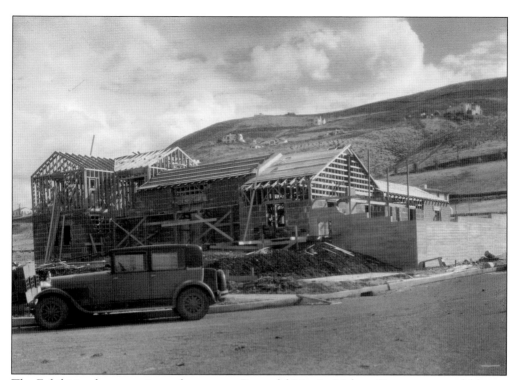

The Exhibition house, as it was known, on Paseo del Mar in Malaga Cove, was a model house commissioned by the Palos Verdes Project. Built in 1927, it was the design of Raymond R. Struthers, an associate of Myron Hunt. A veneer of hollow terra cotta blocks (made by Gladding McBean Company) up to 12 inches thick surrounds the first floor. The home's first owner was Edward I. Martin. The view from May 1928 (below) shows the landscaping, designed by the Olmsted Brothers, beginning to take hold. These images illustrate the practice of Julius L. Padilla documenting the progress of home sites over time. The automobile seen in the foreground appears in many Padilla photographs, leading this author to the conclusion that it may have belonged to him.

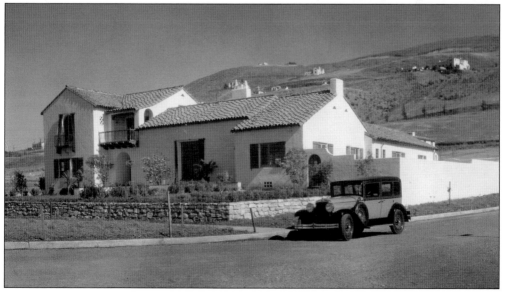

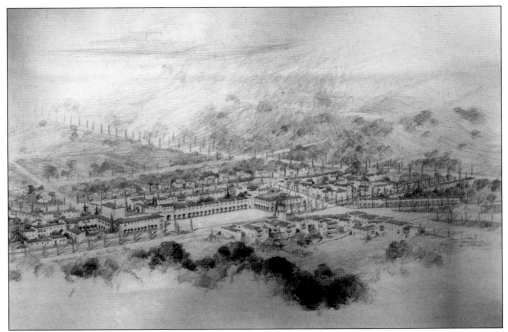

A rendering from 1923 shows the design of Malaga Cove Plaza and surrounding streets. One of six large plazas imagined in the early days of development, Malaga Cove would be the only one constructed largely as designed. Built up in phases over several years, the architects were Webber, Staunton, and Spaulding.

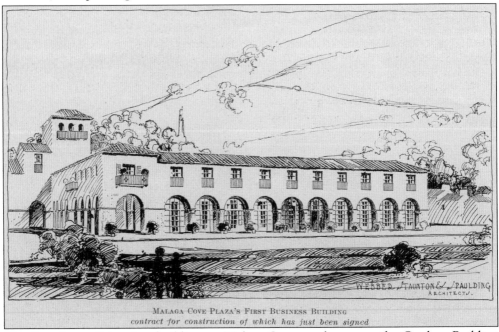

MALAGA COVE PLAZA'S FIRST BUSINESS BUILDING
contract for construction of which has just been signed

The first phase of the plaza buildings at Malaga Cove was known as the Gardner Building originally, after the owner, W. W. Gardner. Construction began in December 1924 and was carried out expeditiously, with its dedication only nine months later. The building has been the heart of Palos Verdes Estates ever since.

September 13, 1925, marked the dedication ceremony for the Gardner Building. It was announced in the February 1930 edition of the *Palos Verdes Bulletin* that it should now be called Casa Primera. This was by decree of the Homes Association, as it was decided appropriate and in keeping with the Spanish named streets and neighborhoods.

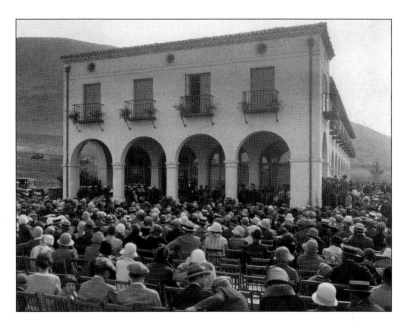

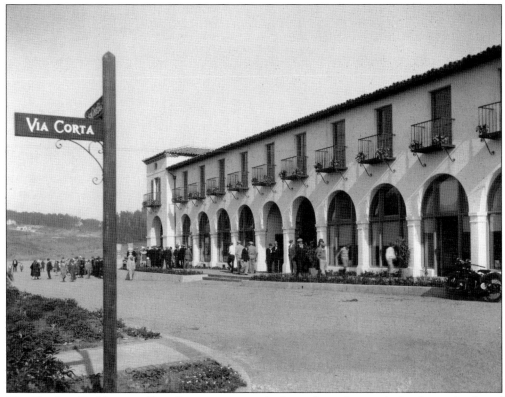

The Gardner Building, or Casa Primera, is seen, looking along the north facade on the day of its dedication. Once complete, the Palos Verdes Project staff immediately relocated its offices from Hotel Redondo, where they had been based previously. The building has served countless purposes over the years.

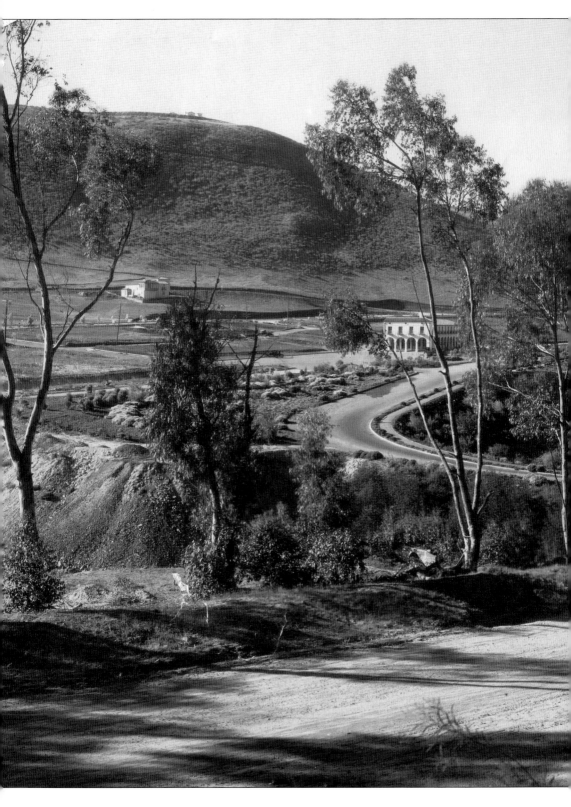

The view west across Malaga Cove along the roads carved through the eucalyptus groves in 1929. The Malaga Cove neighborhood was the heart of the Palos Verdes Estates from the earliest days, being the recipient of the Palos Verdes Golf Club, Malaga Cove School, and the Palos Verdes Beach Club, along with the first plaza (and the only one built largely as originally conceived). The other neighborhoods of Montemalaga, Lunada Bay, Valmonte, Margate, and Miraleste (which the Estates was forced to give up in order to became a contiguous incorporated city in 1939), while seeing some residential building activity, did not develop as rapidly as Malaga Cove. While in time they all developed into charming neighborhoods in their own right, they lack the historical quality of Malaga Cove.

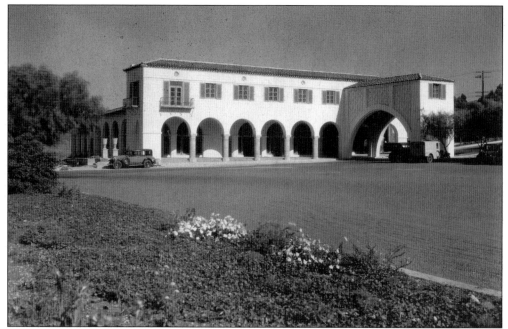

The second building to join Casa Primera at Malaga Cove Plaza's east end was known first as the Alpha Syndicate Building, named for a group of early investors who pooled their funds in order to purchase several choice lots, and later Casa del Portal as the Homes Association wished. It was completed in 1929.

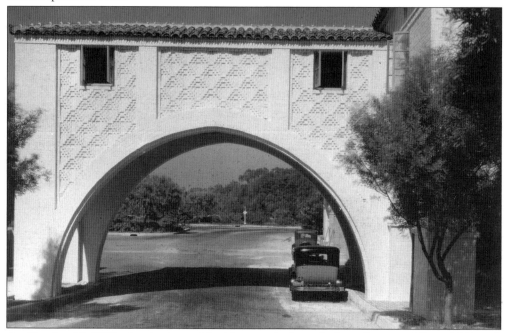

An October 18, 1929, view is pictured looking north through the sally port of Casa del Portal, which spans Via Chica. Over the years, the building was used by real estate brokers, various offices, shops, a bank, a nursery school, as police headquarters, a Boy Scouts meeting place, and during World War II as a Red Cross center.

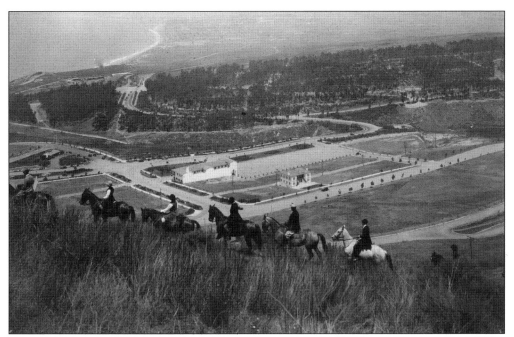

This view was typical of the bucolic imagery that was exploited by the savvy promoters of Palos Verdes Estates. Such images were often used in brochures, magazine advertisements, and in the monthly *Palos Verdes Bulletin*, which was mailed to anyone who asked for it. This view looks down from the hills above the developing Malaga Cove Plaza in 1926.

The east end of Malaga Cove Plaza in 1925 is pictured with flowers abloom in the median. The hills are still vacant and treeless and the road unpaved, but the future was promising, building activity brisk, and the community was taking shape. The signposts that were approved by the Art Jury were lettered in gold against a redwood background.

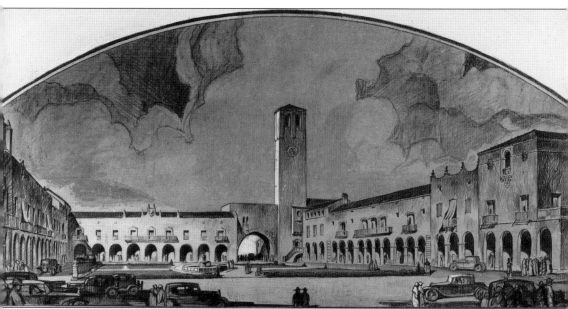

This *c.* 1925 architectural rendering of the approved design for Valmonte Plaza was the work of Marston, Van Pelt, and Maybury, a well-known Pasadena firm, in conjunction with Charles Cheney (consultant in city planning) and the Olmsted Brothers (directors of design). By 1925, an impressive list of architects had either submitted or worked on plans for residences and public and commercial buildings in the developing city. Some of the better known would come to include Wallace Neff, Myron Hunt, Roland E. Coate Sr., Kirtland Cutter, Winchton Risley, Allison and Allison, Edgar Cline, Armand Monaco, H. R. Kelley, John Byers, Sumner Spaulding, and Paul R. Williams, who interestingly, being African American, would not have been allowed to occupy any of the early Palos Verdes Estates homes he designed due to the protective restrictions of the Palos Verdes Homes Association at the time.

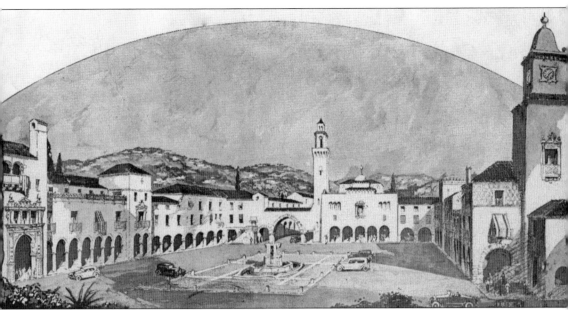

Perhaps the most striking of the unrealized plaza designs (Malaga Cove's being the only plaza built as designed) was Kirtland Kelsey Cutter's design for Lunada Bay. It was a romantic expression of a charming, old Italian town. When Cutter, who had enjoyed a fruitful career in the Northwest (principally Washington), was made aware of the developments in Palos Verdes Estates by an associate in 1923, he did not hesitate to come, as his business was languishing in Spokane at the time. After only two months, he was rewarded with the commission to design Lunada Bay Plaza. While his design was held up as an example of the possibilities of Palos Verdes Estates, it was not to come to fruition for Cutter. Despite the fact that he was 63 when he came to California, he left a lasting mark on the landscape, particularly the 15 or so homes he designed in Palos Verdes Estates.

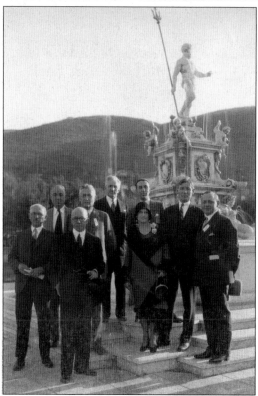

Above, Jay Lawyer (general manager of the Palos Verdes Project) addresses the crowd assembled around the soon-to-be-revealed Neptune Fountain in Malaga Cove Plaza, February 16, 1930. Many dignitaries were on hand to offer congratulations to the people of Palos Verdes Estates, among them C. H. Hammond (president of the American Institute of Architects), Lt. Gov. H. L. Carnahan, Emmile Pozzo (past president of the Italian Chamber of Commerce of Los Angeles), Hugh S. Lawrence (representing Los Angeles County), and John Dennis (mayor of Torrance.) At left are some of the speakers of the afternoon, including Myron Hunt on the left, who presided over the dedication ceremony. The fountain and sculpture is a two-thirds scale replica of a 1563 bronze in Bologna, Italy, by Gian Bologna. The fountain was a gift to the residents of the city by the Palos Verdes Project. When a group of ladies commented about the appropriateness of water spraying forth from the bosoms of the mermaids, Charles Cheney quickly replied, "But ladies, we couldn't afford milk!"

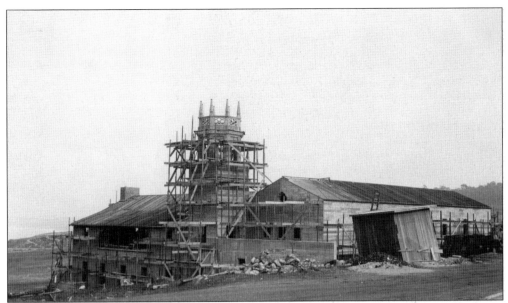

Malaga Cove School was under construction in October 1925. The first school on the peninsula, it opened on April 5, 1926, and was built at a cost of $85,000. The architects, Allison and Allison, received an honor award from the American Institute of Architects for the most notable school architecture in Southern California for the years 1925–1926.

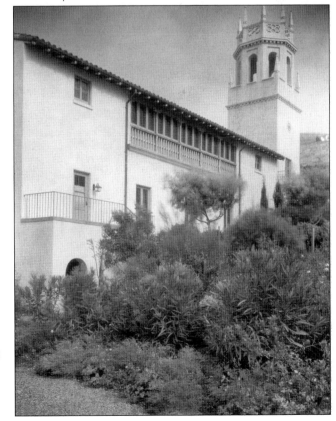

This reinforced-concrete school building took only eight months to build. A later view, 1928, of the school shows the maturing greenery of the Olmsted Brothers–designed landscape. Frederick Law Olmsted Jr. took a keen interest in the landscaping for the grounds. This is not surprising as his home on Rosita Place was directly across from it.

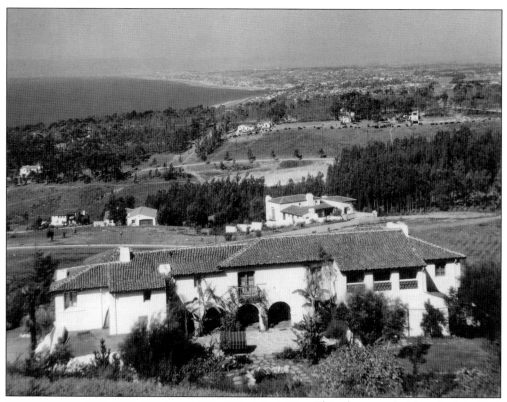

This photograph (above) of the Earl Gard residence on Via Campesina in Malaga Cove is representative of the excellence being achieved in Palos Verdes Estates planning and architecture. The Kirtland Cutter design won the Art Jury's 1927 most notable residential architecture prize. The image shows the Malaga Cove neighborhood taking fine shape, with several homes and maturing landscape on the once bare hills sloping down toward the Malaga Cove bluffs. The date of the image is significant, October 29, 1929, Black Tuesday, the dawn of the Great Depression, which would forever alter the complexion of Palos Verdes Estates. More than 200 people would lose their homes or properties. At left, this lovely image serves as a reminder of the dreams that were dared in the halcyon days of the Palos Verdes Project, the 1920s.

Four

COLECTIVIDAD
A GRACIOUS AND UNIFIED COMMUNITY

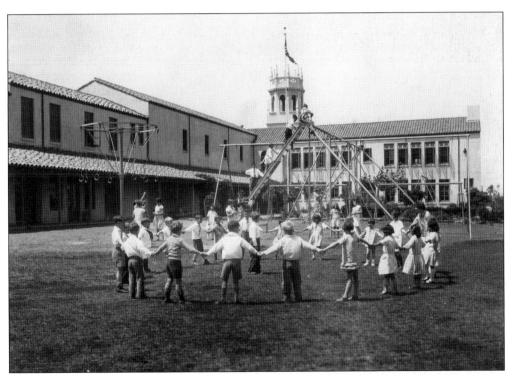

A charming group of schoolchildren join hands on the playground to the east of the Malaga Cove School building. Lifelong Palos Verdes Estates resident Jack Bauman recalls fondly his days at Malaga Cove School: "Because of the small size of the student body, most classes joined together in many activities such as presenting plays, taking field trips, entering the annual birdhouse building contest, entering kite flying contests, planting trees, etc."

September 8, 1925, marked the first term in the new Palos Verdes School District. This classroom, located in the Gardner Building, was one of two used prior to the completion of the Malaga Cove School, which opened on April 5, 1926. The name of the teacher, Miss Hilliard, is on the blackboard. Mildred Hilliard was one of only three teachers who taught at Malaga Cove School upon its opening.

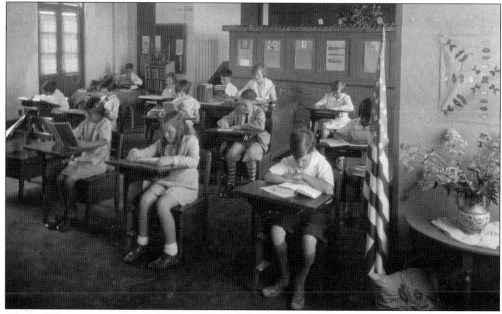

Gladys Garner's room is seen at Malaga Cove School in 1927. She was added to the teaching staff, as reported in the March 1927 edition of the *Palos Verdes Bulletin*. A graduate of the University of California at Berkeley, she previously taught in Fresno and San Diego County. Gladys Garner taught third and fourth grades at the school.

The fifth and sixth grade class of Helen Boughton is depicted in October 1931. Boughton began teaching at Malaga Cove School in 1927. She had two years at Los Angeles Junior College and three at the University of California. Previously she taught at Huntington Beach and Pomona.

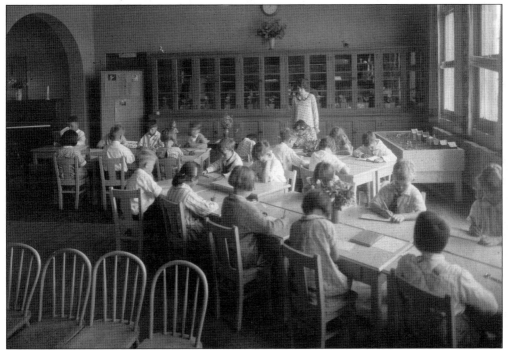

Genevieve Kendall's primary class at Malaga Cove School is seen in 1928. Kendall specialized in music at Washburn College in Topeka, Kansas. An upright piano is visible to the left. Kendall previously taught in Pueblo and Denver, Colorado, and in Ontario, California.

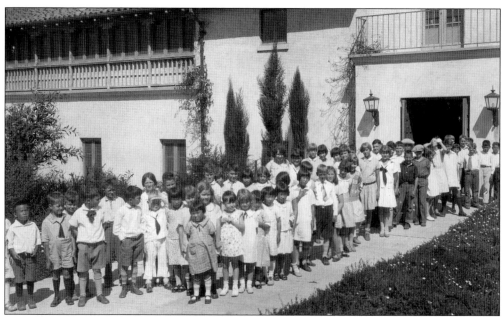

September 12 was opening day at Malaga Cove School in 1927. With 63 students enrolled at the start of its third year, Malaga Cove School served the needs of the new residents as the community grew and also the children of the several Japanese farming families who, since the early 1900s, had worked the land on the peninsula. Below, chief of police William Woosley poses with a group of Malaga Cove School children, May 1929. Every school day at three, when the closing bell rang, Woosley would load as many kids as he could into his cruiser and haul them up to Malaga Cove Plaza to catch the bus. Among the children pictured are James, Emil, Caroline, and Mary Woosley; Keegan Low; Spencer Moeller; Betsy Martin; Richard Yarnell; Bob Patton; Betsy Schellenberg; Jack Wallace; and Jason Cedarholm. The shadow of the photographer, almost certainly Julius Padilla, appears near the bottom of the photograph.

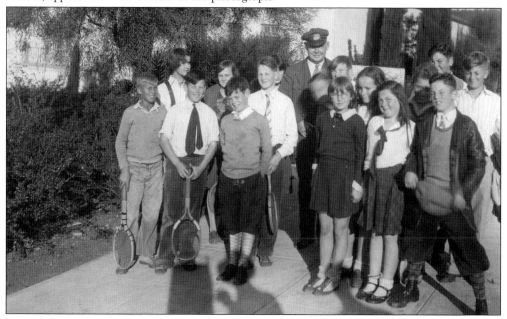

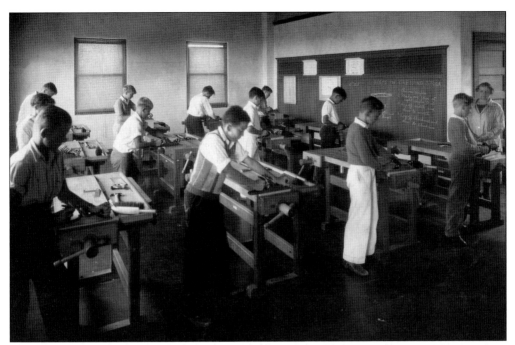

The Malaga Cove School Manual Training classroom is glimpsed in October 1929. Seen here using wood planes, the boys are learning the steps in dressing stock under the direction of Enid Daniel Jones. A highly credentialed educator, Jones joined the faculty in 1929 as director of Manual Training, as well as taking charge of the first and second grades. The Manual Training movement evolved into what we now know as vocational training programs. In the April 1931 photograph below, students show their handiwork, a large puzzle map of the United States. The boys are, from left to right, Joe Tytus, Dann Hough, Bob Gardner, Tom Davis, Tod Snelgrove, Melroy Hodge, Galen Bartmus, Bill Bleeker, and Walfred Runston.

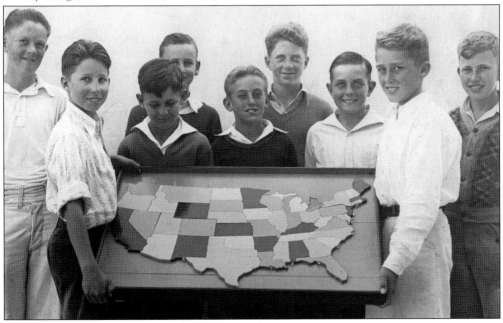

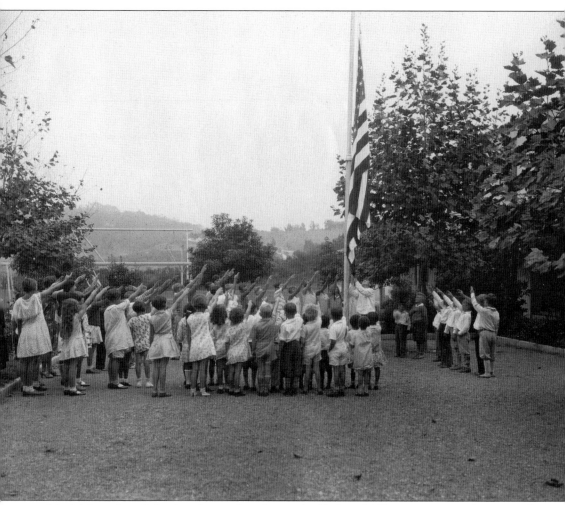

The Malaga Cove School students salute during the Pledge of Allegiance as a teacher raises the flag in October 1930. The children are performing the Bellamy Salute, after Francis Bellamy, who published the original Pledge of Allegiance in the *Youth's Companion Magazine* in 1892. James B. Upham, the nephew of Daniel Sharp Ford, the owner of the magazine, is considered the true author of the pledge. He conceived the schoolhouse flag movement and aimed to place a flag above every school in the nation. The pledge was first used on the 400th anniversary of Columbus reaching the Americas, as a part of a campaign designed to teach ideals of patriotism. The Bellamy Salute was replaced with the hand-over-heart gesture on December 22, 1942, due to its similarity to the Nazi salute.

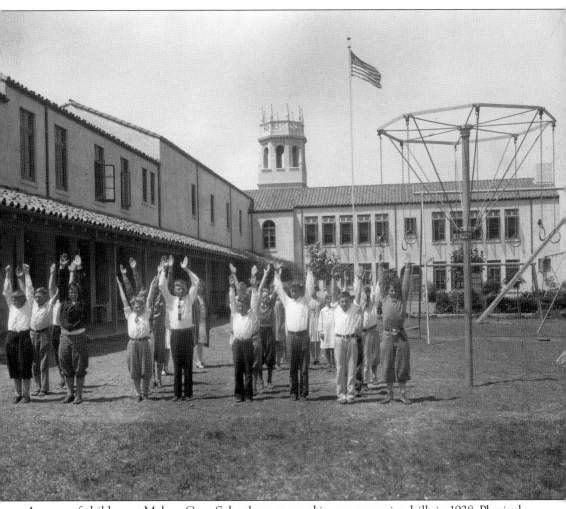

A group of children at Malaga Cove School are engaged in some exercise drills in 1928. Physical Education and athletics were part of the curriculum from the beginning and included baseball, basketball, soccer, football, hockey, volleyball, track, tennis, handball, golf, and gymnastics. Girls were frequently invited to play along with the boys, as there were scarcely enough boys to make two teams. Before long, baseball and other games were arranged with other local schools. Swimming and bodysurfing were added in October 1930 when the new Swimming Club was opened at the base of the cliffs at Malaga Cove, directly across from the school grounds.

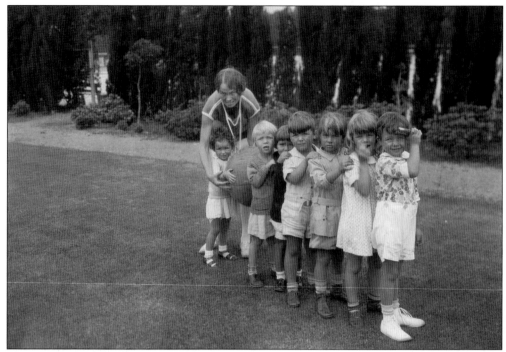

First introduced in 1929, the Nursery Play School provided supervised play (outdoors when weather permitted), French lessons, and music and rhythm to children under six. It was felt that since the homes in Palos Verdes at the time were so scattered and the preschool-aged children somewhat isolated, that they would benefit from this privately funded program. The children were supervised by their mothers under the direction of Gladys Towle and assisted by Thedia Schellenberg (pictured).

On the northwest lawn of the Malaga Cove School, Thedia Schellenberg sits with Nursery Play School children. Among them are Suzanne Sadler, Jean Gilmore, Beatrice Howard, James Armstrong, and Jay Lawyer Jr. The Nursery School program was held at the school for its first year, and then was relocated to the Malaga Cove Plaza on the second floor of the newly built Syndicate Building, which was later known as Casa del Portal.

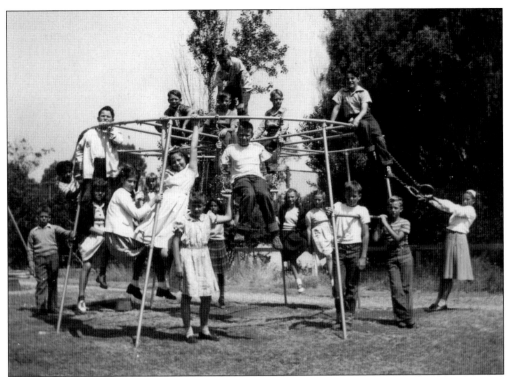

Twenty years after its opening, some unidentified Malaga Cove School children play on the playground equipment. The previously barren landscape is maturing, with the trees now providing shade and protection from the relentless ocean breezes. The trees and shrubs, many of which were planted by students and teachers, came from the project nursery located in Lunada Bay.

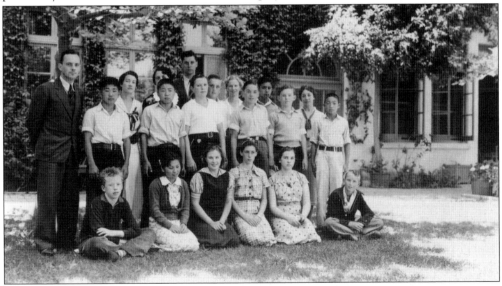

The Malaga Cove School graduating class of 1936 included Leonard Hummel, Tosh Ino, Coza Clausen, Lillian Jones, Atsushi Hirose, George Maclean, La Mar Stewart, John Bauman, Kenzo Uyeno, Erwin Rice, Bill Neale, Bill Kraemer, Edna Sprung, Bill Gilmore, Yeako Miki, Pamela Gwyther, Mary Dale Loomis, and Hale Field.

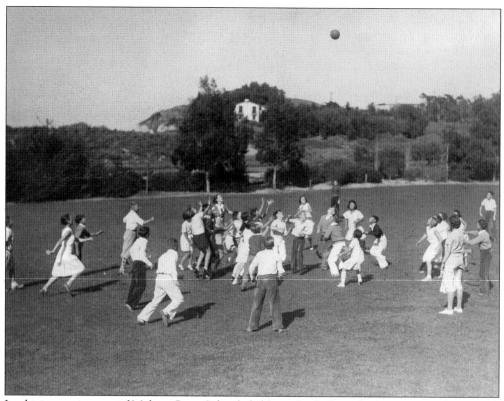

Looking east, a group of Malaga Cove School children play ball on the large grassy playground. The school had 7 acres of open playground space. One can imagine some of the children's mothers peering out their windows down towards the wide open school grounds to catch a glimpse of their child, their view unimpeded by the lush landscaping that would eventually dominate the hillsides. The photograph is from 1928.

Boyd Comstock, early resident and trustee of the school board, encouraged and supported the children in their endeavors. A respected collegiate and Olympic athletic coach, he poses with winners of the Spring Play Day at Malaga Cove School, May 9, 1930. Pictured from left to right are Mary Gilmore, winner of the Arbor Day Award for knowing the most botanical names of plants on the school grounds; Betsy Martin, girls' tennis; Spence Martin, punting; and Jason Cedarholm, boys' tennis.

Arbor Day 1926 was captured here at the newly opened Malaga Cove School. School trustees Romayne C. Martin and Col. John Chambers Low take part in the ceremonial plantings, as did the children of Palos Verdes and their parents, teachers, and friends, as well as other members of the board of education. Under the direction of parks superintendent Farnham B. Martin, flowers and trees were laid out and planted in the school patio and playground.

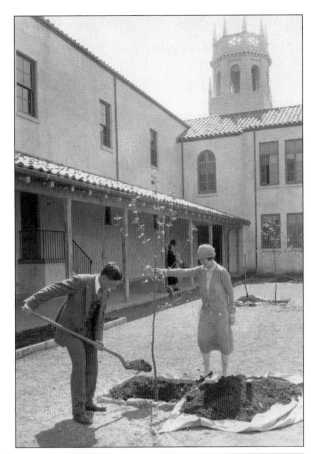

The flower and horticulture show held in the auditorium of the Malaga Cove School, November 16 and 17, 1927, drew a large crowd of garden lovers. Farnham B. Martin, parks superintendent, and James H. Morton, superintendent of the Palos Verdes Nursery, were responsible for the show and were on hand to discuss the various plants fitting the local climate. Arrangements were done by members of the Palos Verdes Woman's Club.

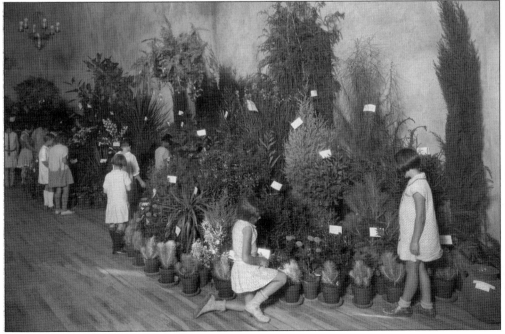

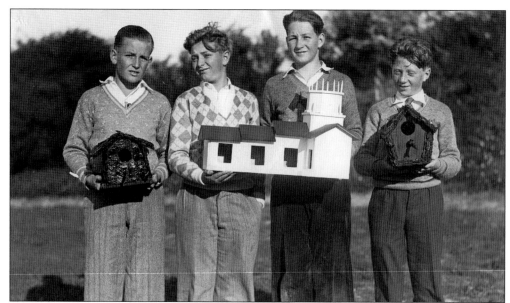

The April 1930 winners of the first annual birdhouse competition sponsored by Frank A. Vanderlip Sr. are pictured here. The boys at Malaga Cove School studied various birds and designed each house to serve a particular species. After the contest winners had been announced, the birdhouses were placed around the school grounds to attract potential tenants. The winners were, from left to right, third prize winner Jack Wallace; Richard Yarnell and Spencer Moeller, who shared second prize; and Melroy Hodge, who won first prize.

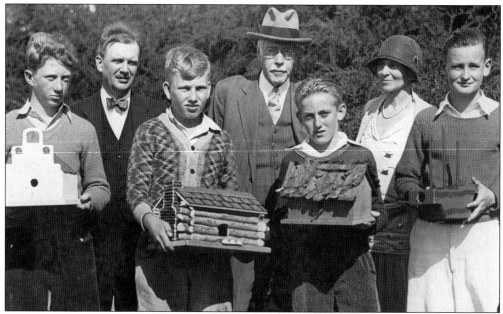

The second birdhouse competition, March 17, 1931, featured nine entries and was judged by Frank and Narcissa Vanderlip, Dr. Ragland and Edward P. Currier of New York, and C. H. Cheney. The winners were, from left to right, Melroy Hodge, Gordon Anderson (first prize), Tod Snelgrove, and Tom Davis. Behind the boys are Charles Cheney (left) and Mr. and Mrs. Vanderlip. Winners were awarded books on architecture and ornithology.

Edith Perry, first principal of the Palos Verdes School District, first served the students as principal and teacher when the school was located in the Gardner Building in Malaga Cove Plaza. Here Perry is in the patio area of the newly opened Malaga Cove School. A native of Indiana, she was educated at Indiana and Purdue Universities. Perry served as principal from 1925 until 1927 when she married Edwin S. Church in New York.

In this 1929 photograph at Malaga Cove School, the following faculty members are pictured: (from left to right) Aurelia Pennekamp (health supervisor); Enid Daniel Jones (first and second grades and director of Manual Training); Lillian S. Jones (seventh and eighth grades); Mary E. Heilman (third and fourth grades, music, and Physical Education director); Edna W. Sprung (principal); and Ruth E. Hunt.

The November 23, 1926, performance of the Thanksgiving operetta (above) *On Plymouth Rock*, under the direction of Genevieve Kendall, marked the first public entertainment at the Malaga Cove School auditorium. The production told the story of John Alden and Priscilla Mullins, played by Harry Martin and Frances Cheney. The role of Capt. Miles Standish went to Ellis Yarnell. The December edition of the *Palos Verdes Bulletin* claimed it a great success. The Christmas school play (below), *Tommy Murphy's Christmas*, was performed in the Malaga Cove School auditorium December 17, 1927. The Christmas program was to generate funds in order to purchase art for the school. Santa Claus was played by James Woosley, brother of the Palos Verdes Estates chief of police.

Riding along the cliffs at Malaga Cove on September 26, 1925, near the future site of the Palos Verdes Swim Club, as it was originally known, were, from left to right, George Bruner; Reba Willis, manager of La Venta Inn; Gladys Towle, who directed the Malaga Cove Nursery School program, which later moved to the Casa del Portal building in the Malaga Cove Plaza; and Howard Harris Towle, who was involved in the early development of the Palos Verdes Project and said to be first resident of Malaga Cove. A large group of riders (below) are in the vicinity of what is now known as RAT (Right After Torrance) beach. A lonely La Venta Inn can be seen on the hilltop in the background. Such excursions were often photographed and used in promotional brochures for the Palos Verdes Project.

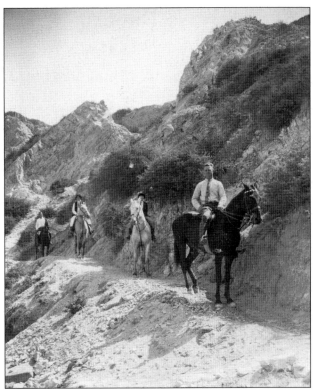

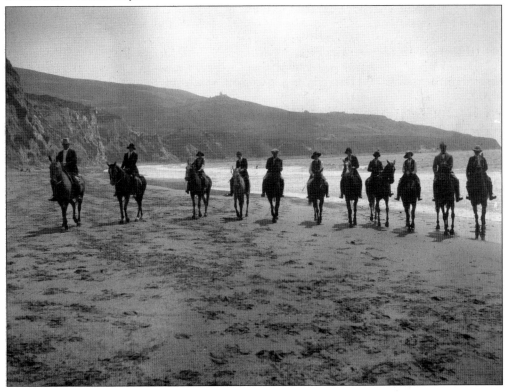

With the number of families coming to Palos Verdes Estates in the boom years of the mid- to late 1920s, most of which had young children, outdoor activities and scouting were promoted. Above, some boys engage in fire building activities around 1927 at the outdoor ovens placed in the extensive woodland park west of the golf course. At left, a group of scouts aboard the sailing vessel *Cachalot* are on the way to Catalina Island in 1936. The boys are, from foreground to background, Larry Stone, John Bradley, A. J. Field, Eddie Hahn, Hale Field, Bill Kraemer, Oliver Hendrickson, Bill Gilmore, John "Jack" Bauman, Marshall Stewart, La Mar Stewart, and Bob Bowker.

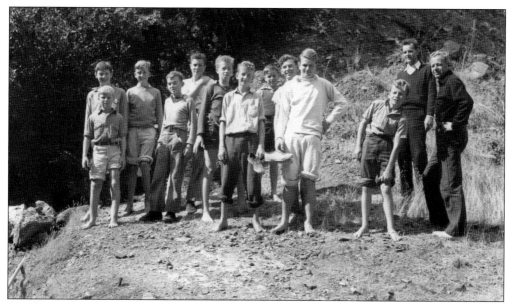

Members of Boy Scout Troop No. 274 explored Catalina Island in 1936. John "Jack" Bauman, who was part of the outing, wrote about the scouts in his 1995 memoir *Peninsula Pastimes*, recalling that there were 15 founding tenderfoots. Meetings were held on the top floor of the Palos Verdes Beach Club until the room burned in 1937. Thereafter, meetings were at Malaga Cove School.

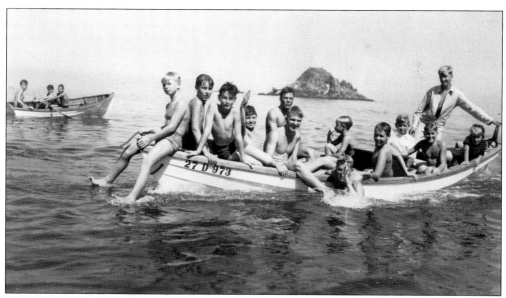

Part of Troop No. 274 is aboard a dinghy at Catalina Island in 1936. In Bauman's memoir, he reminisces about the Sea Scout Patrol formed in 1938 by Jack and seven of his buddies. With the help of the fathers of the scouts, they built a scout house of wood and stone on an acre of Lunada Bay bluff property offered by O. C. Field, the father of two of the boys.

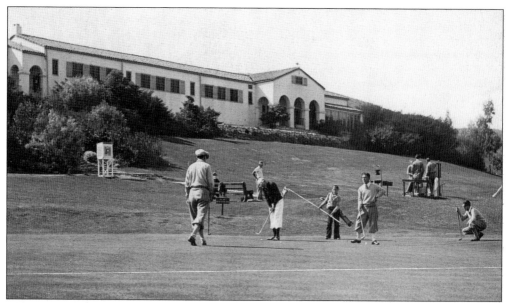

The Palos Verdes Golf Club was in heavy use from its opening in 1924, so much so that only a month later plans to expand the clubhouse were announced in the *Palos Verdes Bulletin*. This March 19, 1929, view looking southwest over the ninth green shows the foursome of (from left to right) Laurence Hussey, Clifford Reid, Al Gruber, and G. H. Morgan along with a caddy. Carl F. Ester (manager of the Palos Verdes Golf Club) is pictured below on August 14, 1929, in front of the dining room of the clubhouse.

James H. Fiske (golf pro of Palos Verdes Golf Club) is seen in an image above from November 1924, right about the time the course officially opened. The November 1924 edition of the *Palos Verdes Bulletin* makes mention of Fiske giving lessons to residents of Palos Verdes, Redondo, Hermosa, San Pedro, Pasadena, and Los Angeles and that he had become popular with experienced and new players. Below, the Palos Verdes Golf Team is seen in a group portrait from February 1926. Members included Mr. Colby, Mr. Dunne, Mr. Eliot, Harry W. Hodges, Lawrence Hussey, Mr. Kirk, Donald Lawyer, Wallace Post, Mr. Rohne, and Mr. Shaw. Jim Fiske (club pro) is standing to the far right.

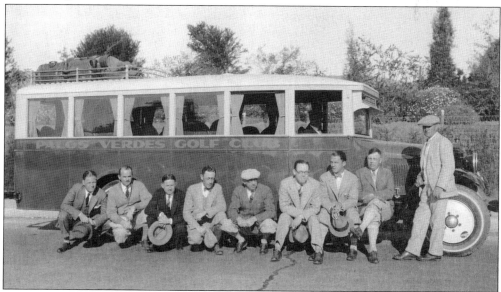

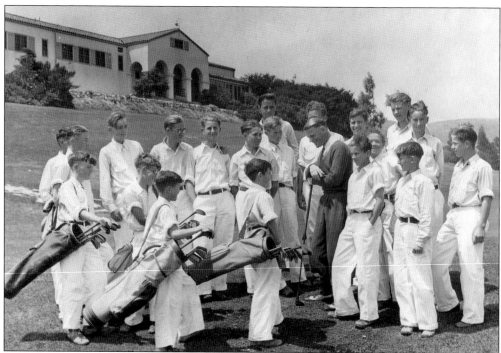

Samuel W. Kripple, the likeable caddy master, club maker, and pro's assistant of the Palos Verdes Golf Club pictured above in May 1926, meets with a handful of his 75-plus young caddies, some of whom appear to be listening intently. Kripple, originally from New Jersey, came to California in 1921. Below is the modest interior of the pro shop of the Palos Verdes Golf Club around 1925. The chalkboard gives the caddie fees as 74¢–$1.50. Clubs are neatly lined up for sale and cartons of new golf balls are displayed at the counter.

Leslie "Les" Henry (secretary of Palos Verdes Golf Club) in this August 1929 portrait (right) was an investment broker and president of the California division of the American Athletic Union. He was a key figure—along with Palos Verdes residents Boyd Comstock, J. C. Low, Walter Braunschweiger, and I. H. Sample—in bringing the Olympics to Los Angeles in 1932. E. D. Slingsby, pictured below in 1926, was the clubhouse manager beginning in April 1926. Previously, he had managed several other establishments, including the Tam O'Shanter Inn on Los Feliz Road in Los Angeles.

Many tournaments were played at the Palos Verdes Golf Club. In this photograph from around 1929, Douglas Palmer hands over the trophy bearing his name to its new owner, Donald K. Lawyer, chairman of the greens committee. The winner of the year was Al Gruber, a promising young Palos Verdes amateur. From left to right are Donald K. Lawyer, Fulton Lane, Douglas Palmer, Nick Bleeker, and Christy Cabanne, a film director.

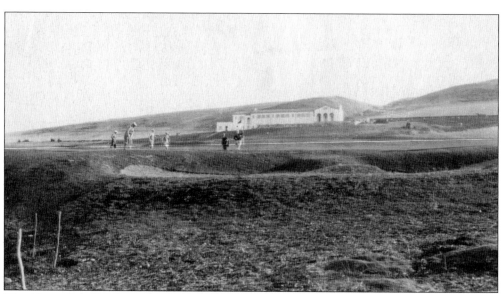

This November 1924 view depicts the recently opened Palos Verdes Golf Club across the 17th green toward the clubhouse. The lack of vegetation on the hills and around the clubhouse imbues the course with the impression of an ancient Scottish links-style course. The Olmsted Brothers designed the clubhouse landscaping and that of the neighborhoods surrounding the course. The course, designed by George C. Thomas Jr., had yet to mature, just like the rest of the newly developed Palos Verdes Peninsula.

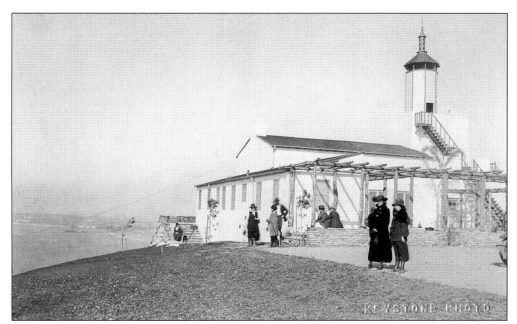

A 1924 image shows some La Venta Inn visitors walking along the barren western exposure of the property. La Venta proved to be an opportune location for the early salespeople of the Palos Verdes Project and also helped the ever growing number of residents eager to entice visits from friends and family. Dinners, dances, luncheons, and teas were held often, and the location was used as a film site and also for weddings. Below, the wedding of Robert Cowley and Mildred Ashby, both from Hermosa Beach, was purported to be the first held at La Venta Inn.

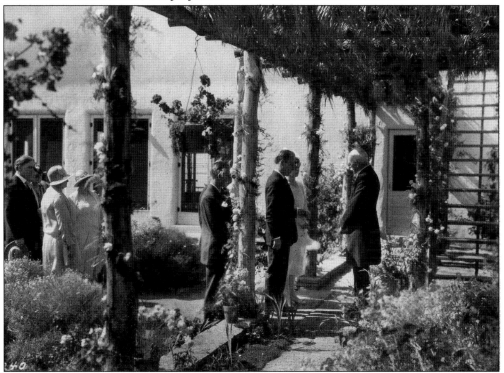

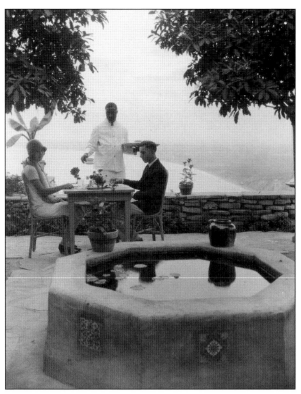

The image at left from October 4, 1924, shows the picturesque north terrace of La Venta Inn where guests could dine alfresco and enjoy the unparalleled view of Santa Monica Bay. A promotional booklet for the inn romantically describes it as the "scenic citadel of the California Riviera." Another passage invites potential guests to "rest awhile on the sun-kissed patio, and view a scene which, at sundown in the fast gathering twilight, might well grace a Turner canvas." Below, a January 1926 view looks toward the north terrace. La Venta Inn was given historical landmark status by the Rancho de los Palos Verdes Historical Society in 1978, the first such designation for the organization.

Five

MANSIÓN DE DIOS
A MANSION . . . A CHURCH

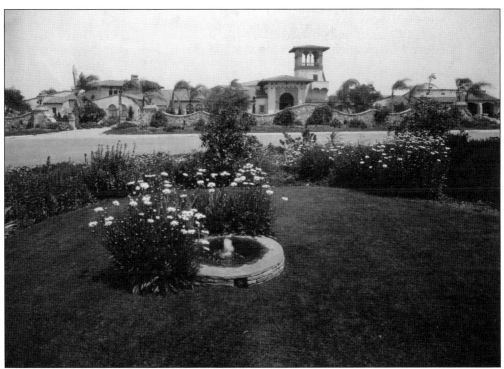

Built in 1927, the summer home of John Joseph Haggarty, a wealthy clothier and department store owner who also dabbled in oil, was the most expensive in Palos Verdes Estates by a factor of around ten and would remain so for decades. The Haggartys' primary home, known as the Haggarty Castle because of its battlements and turrets, was located on fashionable West Adams in Los Angeles. Interestingly, each estate would eventually fall into the hands of a church.

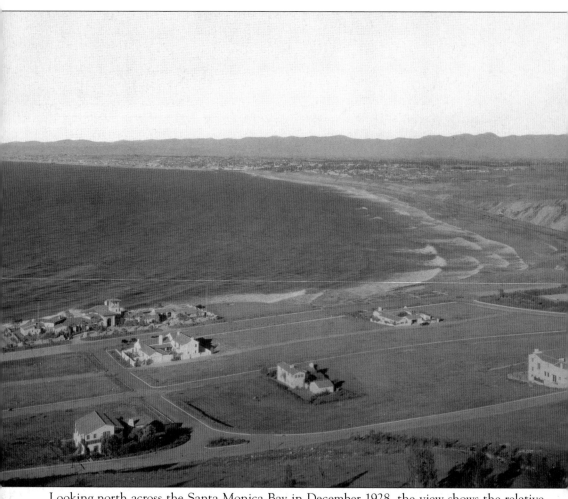

Looking north across the Santa Monica Bay in December 1928, the view shows the relative isolation and the divide that separated the Haggarty's newly constructed Malaga Cove mansion from their West Los Angeles "castle." Bertha Haggarty was accustomed to the Los Angeles social scene, and this no doubt contributed to the fact that the estate was never occupied by the original owners but only occasionally used for weekend retreats and parties. The estate was eventually lost by J. J. Haggerty due to the economic pressures of the Great Depression and was possessed briefly by a number of investors. In the 1940s, Harvey Wheeler, a Midwest inventor and financier, bought the property for a museum of sorts to display his art collection, which, it is said, consisted of an inordinate number of nude statues and paintings. Apparently Wheeler's family, like Haggarty's, preferred their primary residence. When Wheeler died in the late 1940s, his heirs sold the contents and proceeded to put the mansion on the market, by then considered a white elephant because of its huge maintenance costs and taxes.

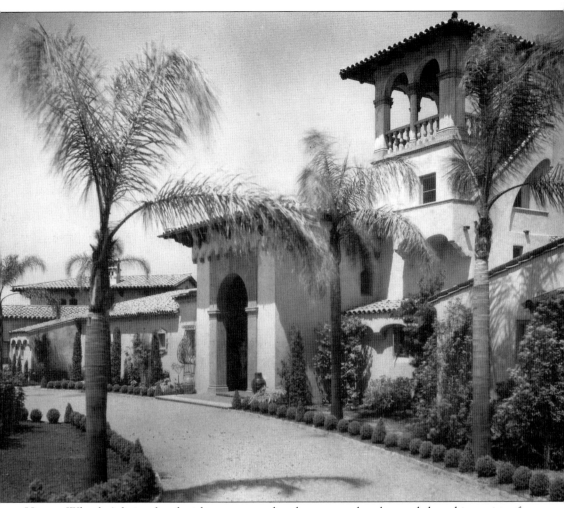

Harvey Wheeler's heirs, faced with a suppressed real estate market, lowered the asking price of the former Haggarty estate several times until, in 1950, it was offered at "only" $250,000, exactly one-third of the cost to build 22 years earlier. It was still out of the reach of even the very well off and did not generate any offers. They lowered the price once more and finally attracted the interest of the members of the Neighborhood Church, a small local community church that held its services in the Malaga Cove School's auditorium but were seeking a more permanent home. A fund drive was initiated and $60,000 was pooled, enough money, they hoped, to make an offer. A well liked resident of Malaga Cove, "Jobby" Jobson was recruited to present the offer. As one of United Airlines first West Coast pilots, Jobson had his route changed in order to connect with the representatives of the Wheeler estate in Chicago. Remarkably, they accepted the lowball offer and the church had its new home.

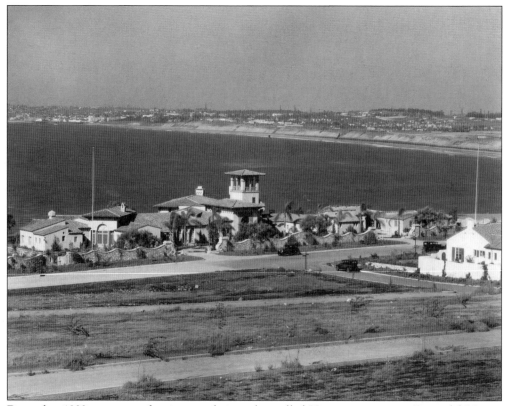

December 1929, one year after its completion, the walled Haggarty estate on Paseo del Mar in lower Malaga Cove stands out in contrast to the more modest home of Edward Martin, which was also built in 1927 and finished in 1928. The Haggarty mansion's architect was Armand Monaco, with landscape design by the Olmsted Brothers firm.

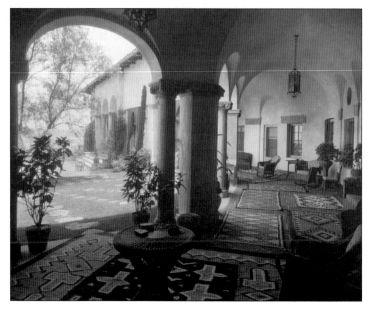

Haggarty, not one to spare any expense, purchased mature specimen olives and palms to hasten the appearance of a seasoned Italian villa. The single-story structure was laid out to match the natural contour of the ocean bluff on which it sat. A colonnaded walkway follows the mansion's north facade. It is interesting to note that architect Monaco's design went through six alterations before it was accepted by the Art Jury.

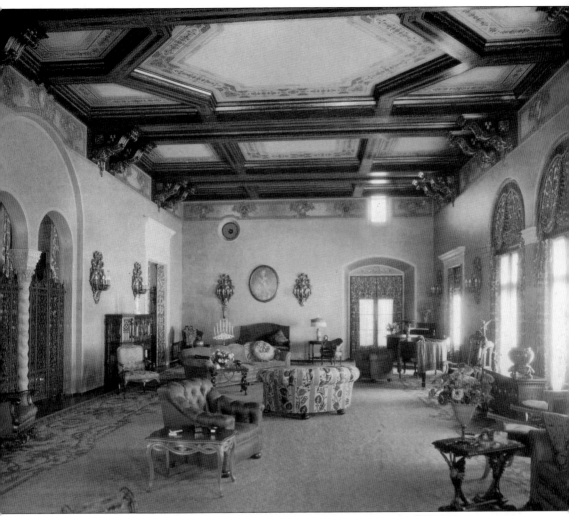

The opulent interior of the Haggarty mansion sheds some light on where the $750,000 construction cost went. The living room shown in this 1928 photograph features large beams and corbels, which were for decoration and not structural purposes. Italianate frescoes and stenciled ceilings and walls were done by A. E. Disi. Haggarty brought artisans from Italy to decorate the mantelpieces and other details at an astronomical sum of $200 per day for the crew (the other tradesmen earned only $5–$10 or so per day). There is reason to believe Alsatian craftsman Ed Trinkeller of Hearst Castle acclaim did the decorative wrought iron, although longtime resident Jack Bauman talks about a local blacksmith from Redondo he was acquainted with as a boy who did some iron work there. The view featured here is looking to the west from what is now the church sanctuary. To allow for the expansion of the sanctuary, the wall that is seen to the rear and the bedrooms beyond are now gone.

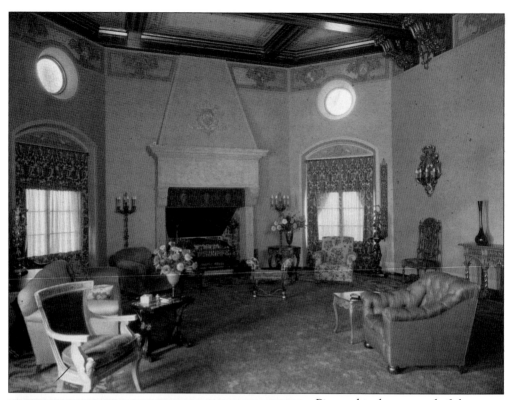

Pictured is the east end of the living room of the Haggarty mansion, September 1928. The chancel now occupies the area where the fireplace was. The fireplace still exists but is now covered by a large pipe organ, which was installed in 1999. The bull's-eye windows now contain stained glass.

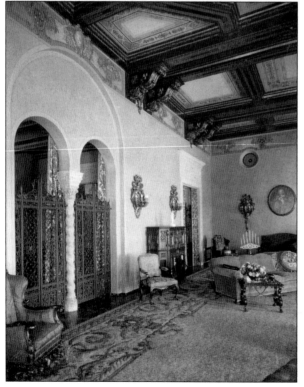

The south wall of the current sanctuary was ornamented with elaborate wrought iron gates set into two large arched openings into what was the dining room. The church now uses the room as a side chapel, opened up for the large congregation during Christmas and other special occasions.

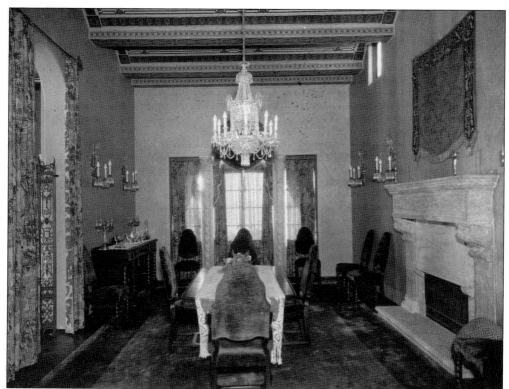

The elegant dining room of the Haggarty mansion is shown with its barrel vaulted and decorated ceiling, crystal chandelier, and a tapestry hanging over the cast stone fireplace. Imagine what the content of the dinner conversation might have been and what guests may have been lured out to the remote estate.

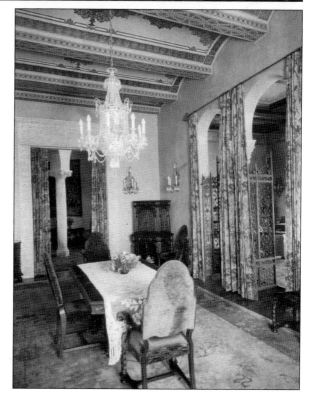

As the story goes, Haggarty was a bit miffed that his mansion was snubbed for the Art Jury's notable homes of 1928, not even garnering honorable mention. Another 1928 view of the Haggarty's dining room looking toward the west shows the fine furnishings of the home. The wrought-iron gates into the then living room stand open. The exquisite detail of the stenciled ceiling is evident in this photograph.

Jack Bauman recalls in his memoir *Peninsula Pastimes, Recollections of an Oldtimer* his teenage years in the 1930s and 1940s, wandering the grounds of the Haggarty estate. He describes watching gliders being towed behind Model T Fords and being launched from the Hollywood Riviera hills into the prevailing onshore winds, then landing on Paseo Del Mar, directly in front of the Haggarty mansion. According to Bauman, the gliders were made of balsa wood and some sort of fabric. He also mentions a world's record flight of 14 hours being recorded here. Indeed the area was noted in a 1938 issue of *Soaring Magazine*, where there is discussion of gliding activities as early as 1928 at Malaga Cove. The article discusses the various take-off and landing points, the scenery, and boasts of three-and-a-half-hour flights with 5,000 feet of altitude gain. Apparently some of the gliders would land in the Japanese vegetable gardens, until—at the urging of the sheriff—the boys found more suitable landing areas.

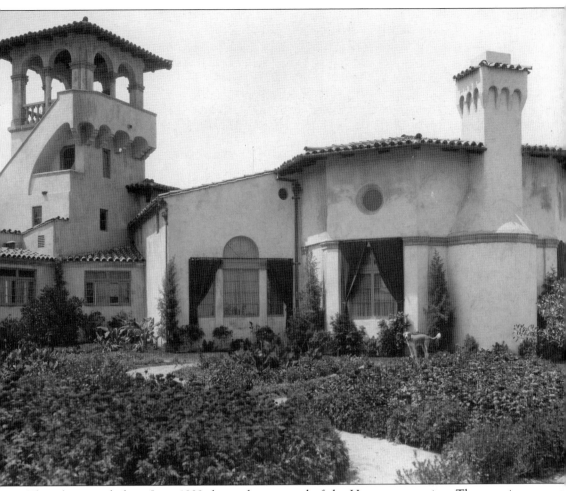

This photograph from June 1929 shows the east end of the Haggarty mansion. The exterior leather drapes were not uncommon for Spanish Colonial Revival and Mediterranean homes of the era. The chimney on the right served the fireplace at the east wall of the living room, now covered by the pipe organ installed by the building's current owners, the Neighborhood Church. Again referencing Jack Bauman's memoir, as a teenager he recalls peeking through the property gates, longing for a closer look at the mysteries that lay beyond. In time, he was befriended by the caretaker of the property, who allowed him to explore the grounds and use the property's pier for fishing, accompanied by the grounds' watchdog, Lavar, a very large Great Dane (obviously not the dog pictured here). With the addition of an Olympic-sized outdoor pool, grottos and caves, and a miniature golf course, it must have been hard to keep curious kids out.

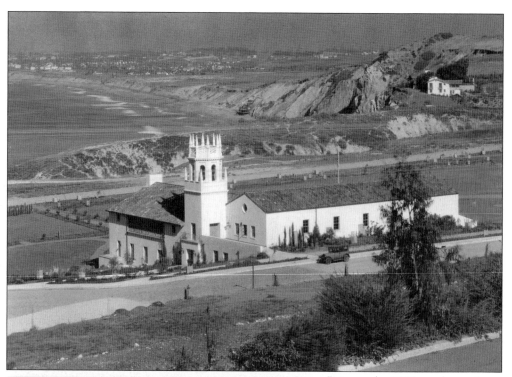

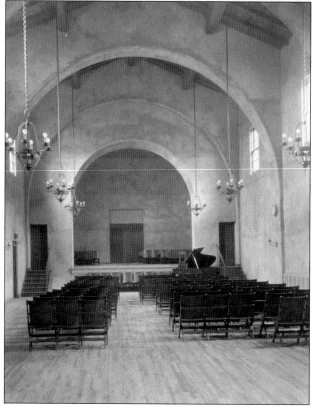

Prior to the 1950 purchase of the Haggarty mansion, the Woman's Club (established February 10, 1926) met at the residence of James and Hazel Dawson (landscape architect with the Olmsted Brothers). The club concerned itself with civic and community matters such as school, church, library, and social activities. In June 1926, the group began organizing small Sunday school classes, which were held in the sunroom of the Gibbs residence on Via Campesina. Later the same year, permission was granted by the school district for the use of the Malaga Cove School auditorium for the growing nonsectarian group. The auditorium (left) provided much needed space, as attendance had grown steadily along with the community.

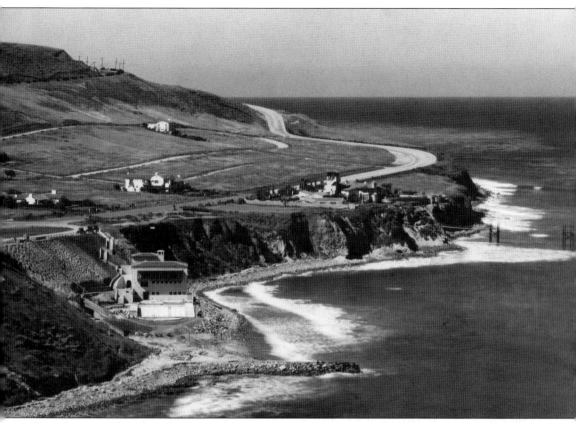

Over the years, there have been numerous interesting stories about the Haggarty mansion, some substantiated, others still a mystery. There were rumors that it was haunted, and there had long been speculation that Haggarty's pier (seen in this image from around 1930) received shipments of booze from time to time during Prohibition. Although it has been scoffed at by some, the eyewitness account of Henry Martin, son of Farnham Martin, as described in a 2001 interview by Al Weber, rings true. In it he tells of several men unloading dozens of cases from boats and stashing them along the seawall. He mentions having seen the same sort of activity at Bluff Cove. He remembers well due to the fact that one night, after going for a closer look, he narrowly escaped the notice of some of the Italians who were driving up the road after picking up the latest shipment.

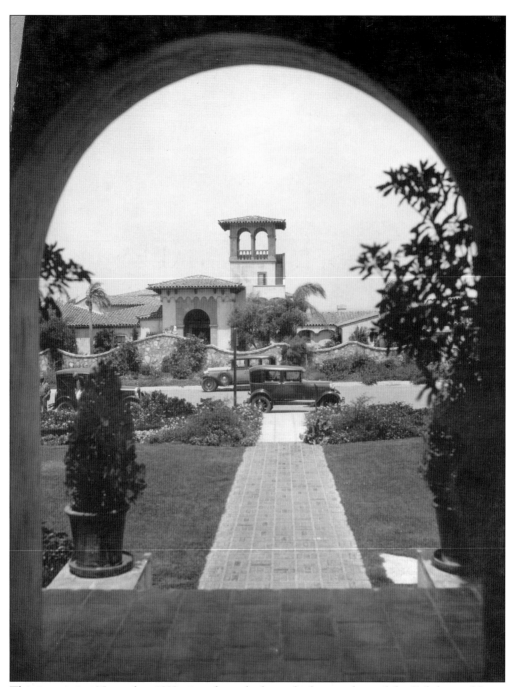

This interesting November 1929 view through the arched entry door of the Exhibition House (model home for the Palos Verdes Project) artistically frames the tower and vestibule of the Haggarty's mansion directly across Paseo del Mar. The two homes were built simultaneously but for dramatically different sums. While Haggarty spent $750,000, the Exhibition House was offered for sale for $75,000, giving some idea of the disparity. The two homes have stood the test of time, as have many Palos Verdes Estates homes of the period, and look remarkably as they did in the late 1920s.

Six

LOS ESPECIALES
SPECIAL PEOPLE, SPECIAL PLACES

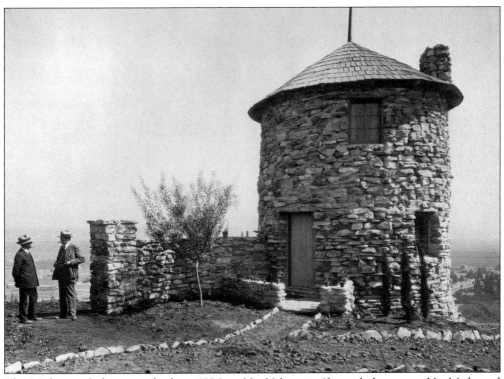

The Mirlo gate lodge tower built in 1926 on Via Valmonte (formerly known as Via Mirlo and Hawthorne Avenue) was designed by C. E. Howard, architect and building commissioner, until the position was taken by Brooks Snelgrove. The structure became a designated historic landmark on September 19, 1988, by the Rancho de los Palos Verdes Historical Society. Howard had an affinity for working with stone and designed several structures in this organic style.

Farnham Battles Martin (superintendent of parks and planting for the Palos Verdes Homes Association) is seen in a portrait taken on June 4, 1926. Martin studied civil engineering at Princeton before joining the Olmsted Brothers landscape architecture firm. He came to the Palos Verdes Project in 1923 and would spend the rest of his tragically few days helping to shape the community that he loved.

Romayne C. Martin, wife of Farnham Martin and active community member, is seen in November 1926. She was trustee and secretary of the Palos Verdes School Board and chairman of the Library Board of the Homes Association. As one of the earliest residents of Palos Verdes Estates, she was central to early women's group, civic, and social activities. She was known to have been an exceptional pianist.

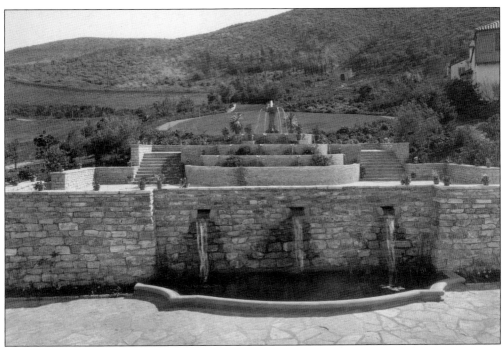

Above is the beautiful park named for Farham B. Martin with its lovely stone fountain in Malaga Cove. On December 19, 1928, Martin was involved in a terrible automobile accident that claimed his life. George Gibbs, a coworker and no doubt close friend of Martin's, was also in the car, along with his wife and daughter, but they escaped serious injury. The loss of Farnham was felt deeply in the community and it was quickly decided that a park would be named in his memory. Below is another view of Farnham Martin's Park. Malaga Cove Library would soon be built immediately to the east of the park.

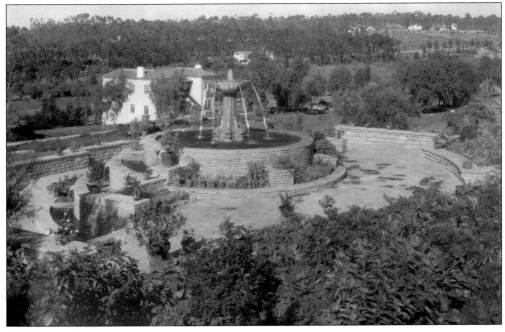

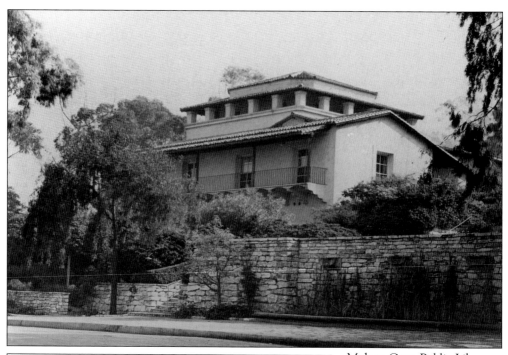

Malaga Cove Public Library and Art Gallery opened on June 3, 1930, with an evening reception and art exhibit. The dedication would follow on June 27. The main floor is entered from Farnham Martin's Park. The design was by Myron Hunt (president of the Art Jury) and H. C. Chambers.

An interior view of Malaga Cove Library is pictured around 1930. The furniture pieces were replicas of original Italian Renaissance pieces owned by Frank A. and Narcissa Vanderlip that were made by the Palos Verdes Furniture Guild under the direction of woodcarver Meredith Watts. The 15-foot-long refectory table was the gift of the Vanderlips; the balance of the furniture was sold at cost to the library.

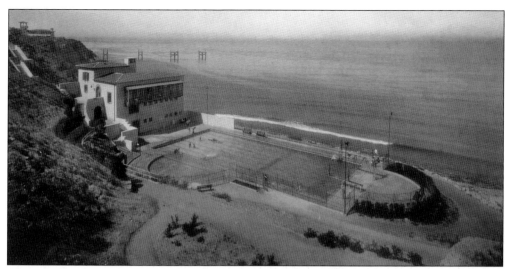

The Palos Verdes Project opened the completed Swimming Club located at the base of the bluffs at Malaga Cove on June 1, 1930. With its saltwater pool, wading pool for children, lounge, and common areas, it quickly became another center of Palos Verdes Estates' social and recreational activities. Below is a closer view of the building designed by Kirtland Cutter (previously of Spokane fame), prolific architect of Palos Verdes Estates and second only to Winchton Risley in the number of homes designed. The Swimming Club, later known as the Palos Verdes Beach Club, was used by the students of Malaga Cove School as part of their physical education curriculum. Both images are from around 1930. The photograph below was one of many used in the promotion of the Palos Verdes Project (see postcard on page 45).

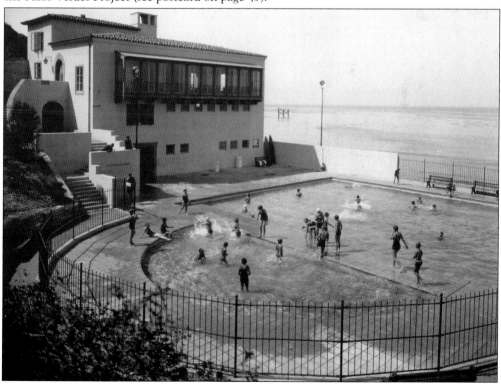

The Memorial Garden, as it appeared in 1949, is located on the corner of Palos Verdes Drive West and Via Almar in Malaga Cove. Hammond Sadler, an early employee of the Olmsted Brothers, took the lead in designing the Memorial Garden, which included a plaque for his son Dendy, who was killed in World War II. The names of John "Jack" Bleeker and Morris Shipley, also killed in World War II, appeared on the original pedestal as well.

In March 1994, at the direction of Mayor Mike Moody, the memorial site was refurbished and redesigned to include veterans of other conflicts and to remember Tom Vanderpool and Michael Tracy, two police officers who were killed on February 14, 1994. The names of Gordon Blackwood, Carl Creal, and Richard Sellers Jr. (all killed in Vietnam) were added. Following the events of September 11, 2001, a new monument was designed. One resident, Christopher Larrabee, was among those who lost their lives that day. (Photograph by the author)

Palos Verdes had its share of famous visitors. In September 1925, La Venta Inn was chosen as a location for the film *The Girl from Montmartre*, a silent film featuring Barbara La Marr and Lewis Stone (pictured here) based on the book *Spanish Sunlight* by Anthony Pryde. This would be La Marr's last film, as she died of tuberculosis three months after shooting the film.

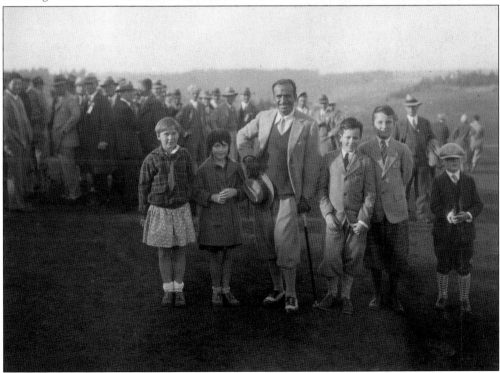

Douglas Fairbanks Sr. visited the Palos Verdes Golf Club in December 1927 during the $2,500 Palos Verdes Open to the delight of some of the local children and adults alike. The youths pictured with the famous actor all belong to prominent citizens of Palos Verdes Estates. From left to right are Betsy Martin, Jane Low, Keegan Low, Harry Martin, and Eugene Etter.

A gentleman stands in front of the Palos Verdes Market, located in the Gardner Building, or Casa Primera, September 11, 1926. The establishment would subsequently be known as the Murphy Grocery and Meat Market, Leonard's Grocery and Meat Market, and finally, Moore's Market.

An interior view from April 1927 of Murphy's Grocery and Meat Market at 78 Malaga Cove Plaza in the Gardner Building, or Casa Primera, is shown here. The September 1926 edition of the *Palos Verdes Bulletin* states that N. J. Murphy took over the market from the previous owners on September 11, 1926.

This interior image from January 1927 depicts the Bruce Drug Store in Malaga Cove Plaza. The November edition of the *Palos Verdes Bulletin* announced this "greatest recent addition to the Palos Verdes community" and comments on the handsome tile and mahogany woodwork. It was fully equipped with a lunch counter and soda fountains. (They were known to make excellent lime rickeys and cherry cokes.)

A December 1926 image shows the interior of the small post office at Malaga Cove Plaza where a woman checks her mail. It was announced in the *Palos Verdes Bulletin* that on August 22, 1925, the Post Office Department in Washington had granted the petition for a new post office to be known as Palos Verdes Estates, California. E. L. Etter was appointed postmaster.

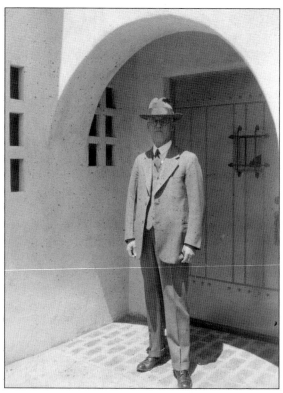

Theodore H. Pennekamp (director of finance for the Palos Verdes Project) is pictured in front of the entryway to his residence on Paseo del Sol, May 3, 1927. Pennekamp came to California from Topeka, Kansas, where he was an accountant and auditor. He was the first employee of the Commonwealth Trust Company, who later became the Palos Verdes Project trustee when the project was reorganized.

Elvon Musick (counsel for the Palos Verdes Homes Association and Palos Verdes Project) is seen in a portrait dated November 26, 1926. A graduate of the University of Southern California, he practiced law in Pasadena for several years before becoming trust counsel of the Title Insurance and Trust Company of Los Angeles.

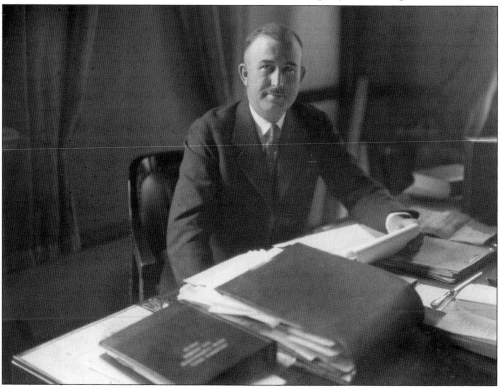

James C. Rous Jr. (superintendent of construction for the Palos Verdes Project), shown here in June 1926, worked under Col. J. C. Low. Rous was in charge of building and surfacing of the roads, installation of storm drain and water systems, and similar infrastructure projects.

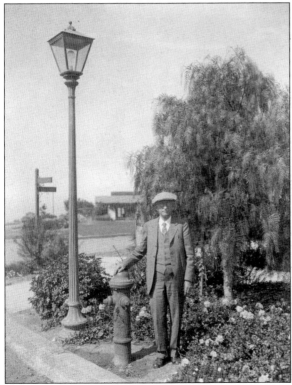

R. E. Brownell (engineer for the Palos Verdes Project and general manager of the Palos Verdes Water Company) is shown here on October 5, 1926. He previously worked as assistant engineer of the South Park System in Chicago, which included the site of the 1893 World's Columbian Exposition. He came to Palos Verdes in 1922.

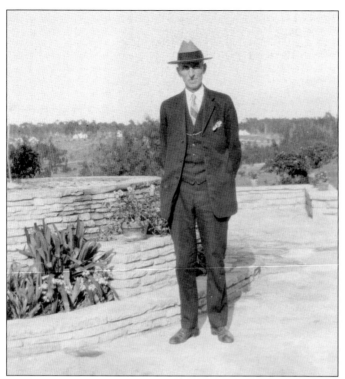

William H. Munroe, landscape architect with the Olmsted Brothers design firm, is seen in an October 1929 portrait at Farnham Martin's Park. He would become superintendent of parks by 1930. Munroe was an early resident. His Kirtland Cutter–designed home (below) was located amongst the eucalyptus groves on Via Anita in Malaga Cove.

This charming Malaga Cove home is that of Raymond R. and Dr. Alice Ball Struthers. Struthers, a Palos Verdes architect once associated with Myron Hunt and longtime Palos Verdes Art Jury president, had designed several home in the Estates including the Exhibition House on Paseo del Mar. He and his wife came to Palos Verdes Estates in 1926 and were one of the first 12 families to settle here.

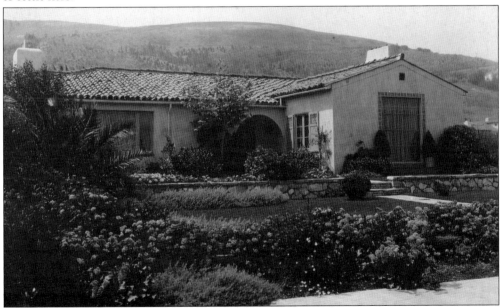

Winchton Risley, the most prolific early Palos Verdes Estates architect, designed the Schmidt residence, pictured here in September 1929. This home was the winner of the Art Jury's Certificate of Honor for the most notable residence architecture of 1926. The charming courtyard home with an unobstructed ocean view across Santa Monica Bay is largely unchanged from its original form.

123

An interior view from November 1930 shows the interesting circular dining room of the Lower Malaga Cove residence of Kate Crane-Gartz, Pasadena plumbing fixture heiress. It was reported that author and California gubernatorial candidate Upton Sinclair stayed awhile at the home of his friend Crane-Gartz following his failed campaign in 1934. The home was designed by the iconic Wallace Neff, the solitary design of his that was built in Palos Verdes Estates. There were plans approved for a large home on Via Rincon for well-known soprano Amelita Galli-Curci in 1930, but it was never constructed.

The grand living room of the Charles H. Cheney residence is pictured around 1925. Cheney was Palos Verdes Project city planner and an Art Jury member from its inception in 1922 through 1944. Both he and his wife, Cora, were devoted pioneer citizens from the earliest days of the city. Located on four separate lots in Malaga Cove (his own design and that of C. E. Howard), it was and remains a stately home of Palos Verdes Estates.

This graceful interior is of the Eulogio "Jack" Carillo residence on Via Campesina in Malaga Cove. The home, built in 1924, was the *Los Angeles Examiner* prize-winning design of Leffler B. Miller. Carillo was the chief engineer of the Shattuck and Eddinger Construction Company, which had contracts for road building in Palos Verdes Estates. He was also the brother of famous actor Leo Carillo. The home had some lovely features, including this tranquil courtyard fountain.

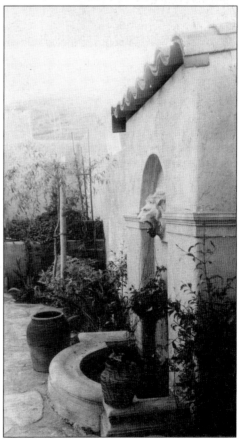

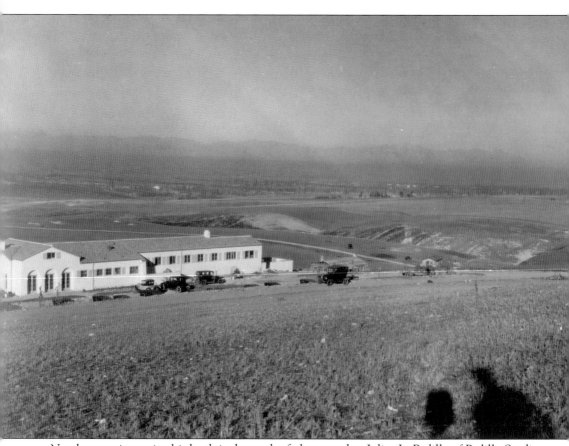

Nearly every image in this book is the work of photographer Julius L. Padilla of Padilla Studios, Los Angeles. Little is known about the man himself, but he has left a wonderful legacy with all the images he captured. He was employed to document the progress of the Palos Verdes Project from the very earliest days, his work appearing in print advertisements, sales brochures, and in the *Palos Verdes Bulletin* from its inception in November 1924. A technique he frequently used was to photograph a home or building from the same angle at different stages of construction and years apart to show the maturing of the plantings and gentrification of neighborhoods. In this final image, a February 1925 view of the Palos Verdes Golf Club, his shadow and that of the camera he used to make so many beautiful images was captured in the lower right hand corner.

BIBLIOGRAPHY

A *Brief History*. Palos Verdes Estates, CA: The Neighborhood Church.

Bauman, Jack. *Peninsula Pastimes: Recollections of an Oldtimer*. Palos Verdes Peninsula, CA: Rancho de los Palos Verdes Historical Society and Museum, 1995.

Fink, Augusta. *Time and the Terraced Land*. Berkeley, CA: Howell-North Books, 1966.

Fishman, Robert. *Bourgeois Utopias*. United States of America: Basic Books, Inc., 1987.

Fogelson, Robert M. *Bourgeois Nightmares: Suburbia, 1870-1930*. New Haven, CT: Yale University Press, 2005.

——— "Protecting Palos Verdes: The Dark Side of the Bourgeois Utopia." In *Regulating Place: Standards and the Shaping of Urban America*, edited by Eran Ben-Joseph and Terry S. Szold, 233–247. New York: Routledge Taylor & Francis Group, 2005.

Frengs, Phil. "Our Community Remembers." *Palos Verdes Bulletin*. Palos Verdes Estates, CA: Palos Verdes Homes Association, Fall 2007.

Gates, Thomas. "The Palos Verdes Ranch Project." *Architronic* 6, 1 (1997), http://corbu2.caed.kent.edu/architronic/.

Lewis, E. G., ed. *The Illustrated Review*. Atascadero, CA: Woman's National Publishing Company, [issues: June 1921–December/January 1924]

Lukas, Betty. Peninsula Past. *Palos Verdes Peninsula News*, sec. 1.

Marsh, Margaret. *Suburban Lives*. Toronto: Rutgers University Press, 1990.

Matthews, Henry. *Kirtland Cutter: architect in the land of promise*. Seattle: University of Washington Press, 1998.

www.maureenmegowan.com

Morgan, Delane. *The Palos Verdes Story*. Palos Verdes Estates, CA: Review Publications, 1963.

Morley, William C., Wilkins Jr., Robert J., ed. *E. G. Lewis, Fraud or Friend?* Atascadero, CA: Wilkins Creative Printing, 1967.

The Neighborhood Church 50th Anniversary: 1939–1989. Jean Landon Taylor, ed. 1989.

The Palos Verdes Bulletin. Palos Verdes Estates, CA: Palos Verdes Homes Association, Spring 2000.

Weber, Emerson A. *The Neighborhood Church: a History: 1925–1985*. Redondo Beach, CA: Sonshine Printing, 2002.

Young, Donald J. *Wartime Palos Verdes*. Palos Verdes, CA: self-published, 1985.

www.arcadiapublishing.com

MAP SEARCH

Discover books about the town where you grew up, the cities where your friends and families live, the town where your parents met, or even that retirement spot you've been dreaming about. Our Web site provides history lovers with exclusive deals, advanced notification about new titles, e-mail alerts of author events, and much more.

MADE IN THE USA

Arcadia Publishing, the leading local history publisher in the United States, is committed to making history accessible and meaningful through publishing books that celebrate and preserve the heritage of America's people and places. Consistent with our mission to preserve history on a local level, this book was printed in South Carolina on American-made paper and manufactured entirely in the United States.

This book carries the accredited Forest Stewardship Council (FSC) label and is printed on 100 percent FSC-certified paper. Products carrying the FSC label are independently certified to assure consumers that they come from forests that are managed to meet the social, economic, and ecological needs of present and future generations.

FSC

Mixed Sources
Product group from well-managed forests and other controlled sources

Cert no. SW-COC-001530
www.fsc.org
© 1996 Forest Stewardship Council

Find Your Place in History.